ALL HAIL
→ THE ←
QUEEN

ALL HAIL THE QUEEN

TWENTY WOMEN WHO RULED

BY JENNIFER ORKIN LEWIS

written by SHWETA JHA

CHRONICLE BOOKS

SAN FRANCISCO

Library of Congress Cataloging-in-Publication Data
Names: Lewis, Jennifer Orkin, author, illustrator. | Jha, Shweta, author.
Title: All hail the queen : twenty women who ruled /
 By Jennifer Orkin Lewis ; Written by Shweta Jha.
Description: San Francisco : Chronicle Books, [2019]
Identifiers: LCCN 2018031273 | ISBN 9781452166735 (alk. paper)
Subjects: LCSH: Queens--Biography.
Classification: LCC D107.3 .L49 2018 | DDC 920.72—dc23
LC record available at https://lccn.loc.gov/2018031273

Manufactured in China.

10 9 8 7 6 5 4 3 2 1

Chronicle books and gifts are available at special quantity
discounts to corporations, professional associations, literacy
programs, and other organizations. For details and discount
information, please contact our premiums department at
corporatesales@chroniclebooks.com or at 1-800-759-0190.

Chronicle Books LLC
680 Second Street
San Francisco, California 94107
www.chroniclebooks.com

FOR MY
MOTHER-IN-LAW
BOBBIE LEWIS

TABLE OF CONTENTS

INTRODUCTION

By JENNIFER ORKIN LEWIS

"Though the sex to which I belong is considered weak you will nevertheless find me a rock that bends to no wind."

—Queen Elizabeth I

This book tells the stories and illustrates the lives of twenty strong, brave women who each became queen of her people. Some were rulers by birth, others through marriage. Nearly all led lives full of dramatic events and intrigue. These monarchs all lived in times when, historically, women didn't have equal status to men—a state of affairs that is sadly still true in many cases today. Had they followed the cultural norms of their times, they ought to have been quiet and unassertive. Each and every one of them overcame those expectations and made her mark on the culture and people she ruled.

I came to this project from the perspective of a painter, and a lover of color, story, and fashion. I've always adored reading books and watching shows about the lives of monarchs, with their soap opera–like drama. Our modern interest in these important women is timely. As we think about women's rights in our own time, there is much to be learned, and inspiration to be drawn, from powerful women who came before. That's one reason I love the stories. But, deep down, my spirit lies with the textiles, costumes, scenery, and visages of these bygone times, which are endlessly fascinating to me.

I worked on each queen one at a time, completely immersing myself in her story, her culture, the trajectory of her life, and what she and the clothes she wore and the world around her looked like. Some are so ancient that my references for how they appeared and where they lived were pulled from crumbling sculptures and bits of old paintings. I dug for information, but I also went about it as an exercise in imagination. Perhaps not every detail in the illustrations is perfectly accurate, but I believe I came close. My goal was to capture the essence. Each chapter is a separate world.

Not every queen in this book is well known like Queen Elizabeth or Cleopatra. In some cases, the forces of history, which are not always just, have made information hard to come by. The Egyptian queen Hatshepsut had the story of her life destroyed and buried because she was a woman; Lady Six Sky's Maya civilization was completely wiped out by the Spanish; and Empress Himiko, who ruled over the hundred islands of the Japanese archipelago in the third century, wasn't rediscovered until the Edo period in 1600. In my art, and writer Shweta Jha's text, we hope to bring these and other stories to life for you in our present day.

Working on this book was an emotional time for me—living in those twenty different worlds—and my hope is that you, too, can live for a short time in the remarkable realms of royalty. It's my dream to share with you my reimagined visions of these women's elegance, individuality, romance, drama, and power. All hail the queen!

HATSHEPSUT

c. 1500 – 1458 BCE

PHARAOH OF EGYPT

Hatshepsut was the fifth ruler of Egypt's illustrious eighteenth dynasty, ascending the throne at the age of twelve with Thutmose II, her husband and half-brother. After his death, she ruled as regent for Thutmose III, the infant son of her brother and another lower-ranking queen. But by the seventh year of her regency, Hatshepsut seized power and began depicting herself as king, appearing on reliefs as a male pharaoh, bearded and bare-chested.

Reigning for nearly twenty-two years, Hatshepsut was the first Egyptian woman ruler with real staying power. Her political ascent boasted economic successes, politically clever moves, and a shrewd use of religious ideology to support her androgynous reign. Hatshepsut was also a prolific builder, commissioning ambitious projects throughout Upper and Lower Egypt. The country flourished under her reign, and it was a time of peace and prosperity, untainted by military disasters or bloody coups.

Yet after Hatshepsut's death, Thutmose III attempted to remove her legacy from history by systematically shattering her buildings and statuary; ironically, the staggering number of her monuments, situated all over Egypt, meant that he couldn't destroy everything. Scholars previously thought this was an act of simple revenge, but now believe it was Thutmose's way of protecting his dynasty's line of succession by eliminating any uncertainty about his son Prince Amenhotep's right to rule. As for Hatshepsut, she vanished from the world for centuries, leaving only the sands to whisper her name.

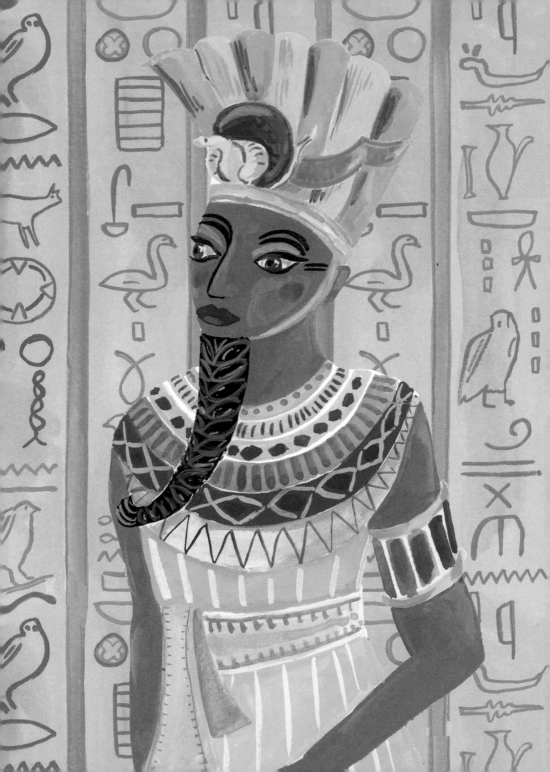

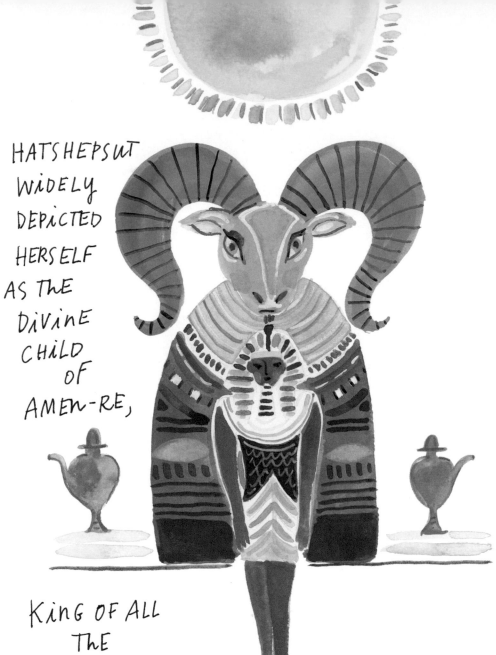

HATSHEPSUT WIDELY DEPICTED HERSELF AS THE DIVINE CHILD OF AMEN-RE,

KING OF ALL THE GODS.

TREASURES BROUGHT BACK FROM THE FARAWAY
LAND OF PUNT DURING HATSHEPSUT'S REIGN
INCLUDED EBONY, WOOD, AND EVEN
LIVE INCENSE TREES.

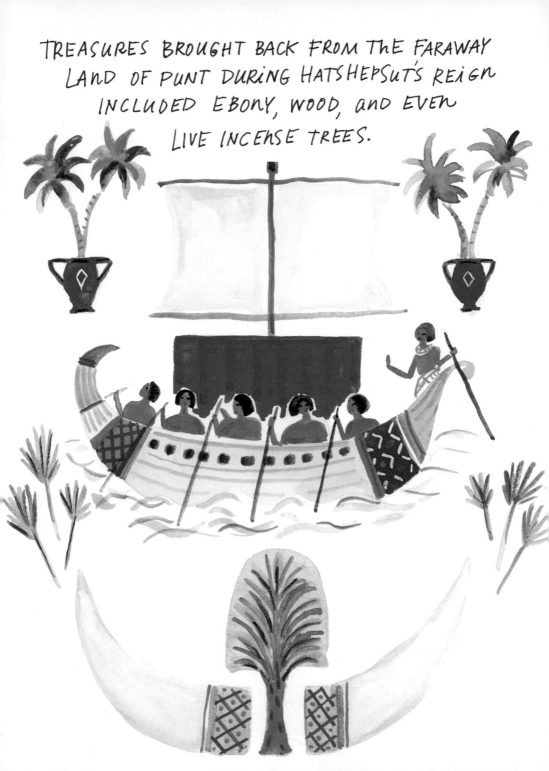

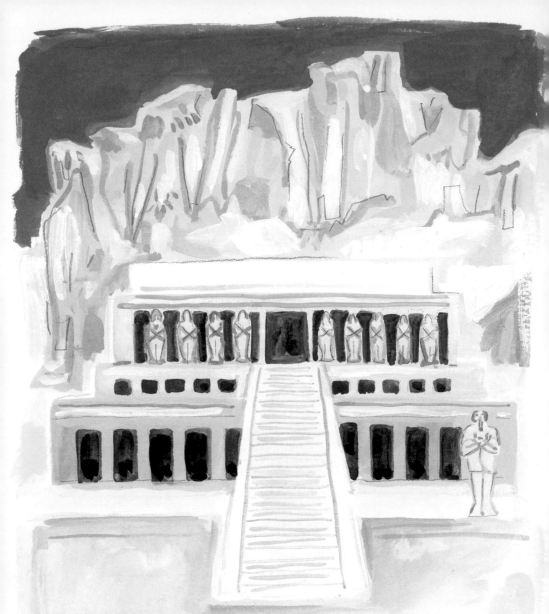

HATSHEPSUT'S ICONIC MORTUARY TEMPLE, DJESER DJESERU ("HOLY OF HOLIES"), WAS AN ARCHITECTURAL WONDER AND SO SACRED AND BELOVED THAT THUTMOSE III LEFT IT INTACT.

TWENTY-FIVE YEARS AFTER HATSHEPSUT'S DEATH,
THUTMOSE III BEGAN A CAMPAIGN TO DENOUNCE
HER KINGSHIP BY DESTROYING HER MONUMENTS
AND REMOVING DEPICTIONS
OF HATSHEPSUT
AS
PHARAOH.

ATOSSA

c. 550 - c. 475 BCE

QUEEN OF PERSIA

Persian queen Atossa was the daughter of Cyrus the Great, who founded the Achaemenid Persian Empire. Her son, the future king Xerxes I, was born around 522 BCE after her third marriage to Darius I, who governed the empire at its peak.

Much of what is known about Atossa comes from the ancient Greek historian Herodotus's *The Histories*, a narrative about the Greco-Persian wars and life at the Achaemenid court. Though the stories aren't entirely accurate—describing, as they do, situations Herodotus did not witness and relying heavily on stereotypes—they are some of the only detailed portraits we have.

Herodotus often touched on Atossa's so-called absolute power over Darius. For example, when it came time to choose which of his sons would be heir, Darius chose Xerxes because of Atossa's high rank and influence. But modern scholars reject this portrayal, arguing that Herodotus's interpretation relies on Greek stereotypes of "overbearing" Persian queens. Atossa also figures prominently in Aeschylus's tragedy *The Persae*, but contemporary analyses say her portrayal as an unnamed wise and suffering queen stems from Greek literary tropes and isn't historically accurate.

Still, royal women were influential, even if they could not guide political or military decisions. Atossa's position as queen certainly afforded her power, and her added role as mother of the heir would have significantly elevated her status—but how this played out remains lost in the mists of time.

ATOSSA MARRIED AT DIFFERENT
TIMES THREE SEPARATE RULERS
OF THE
PERSIAN EMPIRE:
HER BROTHER CAMBYSES;

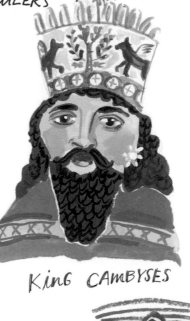

KING CAMBYSES

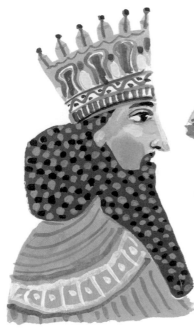

IMPOSTOR KING

GAUMATA (an IMPOSTOR
POSING AS KING BARDIYA);
and DARIUS I.

KING DARIUS

HERODOTUS REPORTS THAT ATOSSA SUFFERED FROM A BREAST LESION, WHICH SHE ATTEMPTED TO CONCEAL.

ONCE iT FESTERED, DEMOCEDES, A GREEK COURT PHYSICIAN, SUCCESSFULLY TREATED iT.

ITALY

MT OLYMPUS

MACEDONIA

ANCIENT
GREECE

HERODOTUS CLAIMS ATOSSA WAS
BEHIND DARIUS'S ATTACK ON GREECE,
BUT THIS WAS LIKELY FALSE.
NEVERTHELESS, DARIUS
ORDERED A PERSIAN INVASION OF
GREECE IN 492 BCE.

PERSIAN EMPIRE

CRETE

OLYMPIAS

c. 373 - 316 BCE

QUEEN OF MACEDONIA

Olympias, mother of Alexander the Great, was a royal princess from Molossia, a distant mountain kingdom in northwestern Greece. She became a powerful—and sometimes ruthless—political force after Alexander took the throne in 336 BCE, forging military alliances, raising armies, and eliminating her enemies to protect her dynasty. After Alexander's sudden death in 323 BCE, she fought valiantly to secure the crown for her grandson, then only an infant, but she failed, and was executed by Cassander, the son of Alexander's regent, who also wanted the throne.

Olympias was one of seven wives of Philip II of Macedonia. His last wife, Cleopatra Eurydice, was known to have committed harmful acts against the family. After Philip was assassinated, Olympias ordered the assassination of Cleopatra Eurydice and her infant daughter, whom she perceived as threats. After her son Alexander's death, Olympias marched from Molossia into Macedonia in an attempt to safeguard the throne, and reportedly her reputation alone incited the Macedonian army to rebel against their commander and join Olympias's fight.

Olympias then commanded the murder of Alexander's mentally handicapped half-brother (who had been appointed as a placeholder to the throne), his wife, and a hundred others who supported her rival. In a terrible betrayal, she was eventually captured and killed by Cassander, who had initially promised to spare her life.

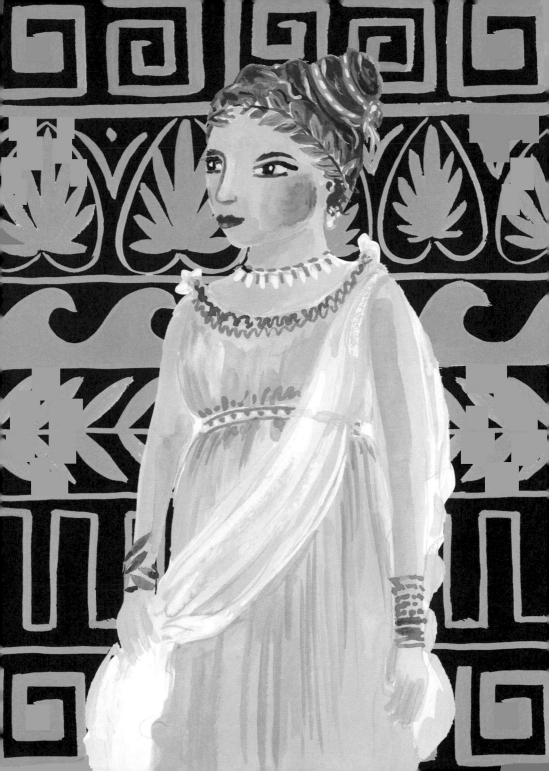

OLYMPIAS, FOND OF SNAKES, KEPT TAMED SERPENTS THAT WOULD WIND THEMSELVES AROUND THE WANDS AND GARLANDS OF FELLOW WORSHIPPERS, ACCORDING TO THE GREEK BIOGRAPHER PLUTARCH.

OLYMPIAS BELIEVED SHE DESCENDED FROM THE GREEK HERO ACHILLES, A CONVICTION THAT DEEPLY SHAPED HER IDENTITY.

ZEUS

POSEIDON

ACHILLES

APOLLO

SHE RAISED ALEXANDER TO BELIEVE HE WAS ZEUS'S SON.

PHILIP'S VICTORY AT THE
OLYMPIC GAMES POSSIBLY INSPIRED
THE MONIKER "OLYMPIAS";

OTHERS BELIEVE IT STEMS
FROM THE ZEUS FESTIVAL, WHICH
FEATURED THE ORIGINAL
OLYMPIC GAMES.

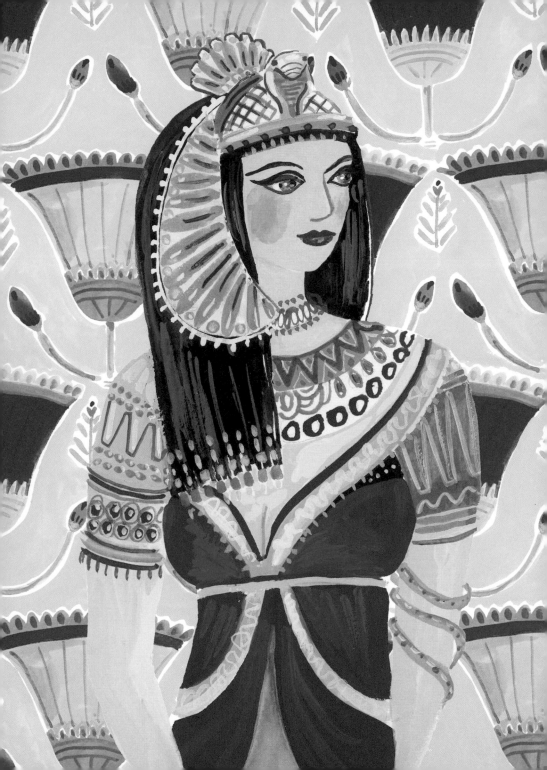

CLEOPATRA

69-30 BCE

QUEEN OF EGYPT

Cleopatra, queen of Egypt, was the most powerful female ruler in all the ancient world. She was only eighteen when she took the throne in 51 BCE with her ten-year-old co-ruler, Ptolemy XIII, who was both her brother and her husband. When she died just twenty-one years later, Egypt succumbed to Roman rule. But in the intervening years, Cleopatra skillfully preserved Egypt's autonomy in the face of Roman aggression while presiding over a vast and prosperous empire. Her allies were also her lovers: Julius Caesar and Marc Antony, Roman generals and the most powerful men in the Republic.

She was highly educated, famously captivating, politically shrewd, and immensely popular among her people. Although not ethnically Egyptian—Cleopatra was part of the Ptolemaic dynasty of Macedonian Greeks who had ruled Egypt for more than two centuries—she was the only member of her line to learn Egyptian and embrace the local culture.

After Julius Caesar's assassination, she joined forces with Antony, which assured her continued power but infuriated Rome. In 32 BCE, Roman military commander Octavian declared war on Cleopatra. During the Battle of Actium, Cleopatra and Marc Antony's naval fleet was destroyed, and their luck soon ran out. Antony died in Cleopatra's arms, and she committed suicide.

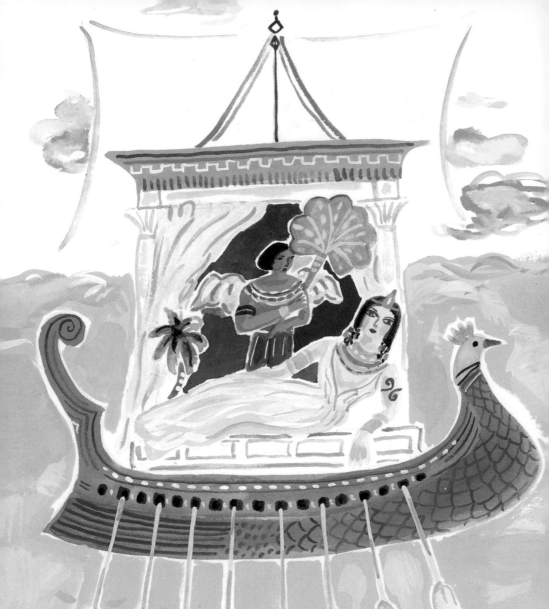

RECLINING UNDER A GOLD-FLECKED CANOPY, DRESSED AS APHRODITE, CLEOPATRA SAILED INTO TARSUS ON A BARGE WITH PURPLE SAILS AND SILVER OARS TO MEET MARC ANTONY.

WHEN PTOLEMY XIII EXILED CLEOPATRA FROM THEIR KINGDOM,

SHE SMUGGLED HERSELF INTO CAESAR'S QUARTERS AND WON HIS SUPPORT TO HELP GET HER THRONE BACK.

MARC ANTONY AND CLEOPATRA FORMED a HEDONISTIC DRINKING SOCIETY CALLED the "Inimitable Livers,"

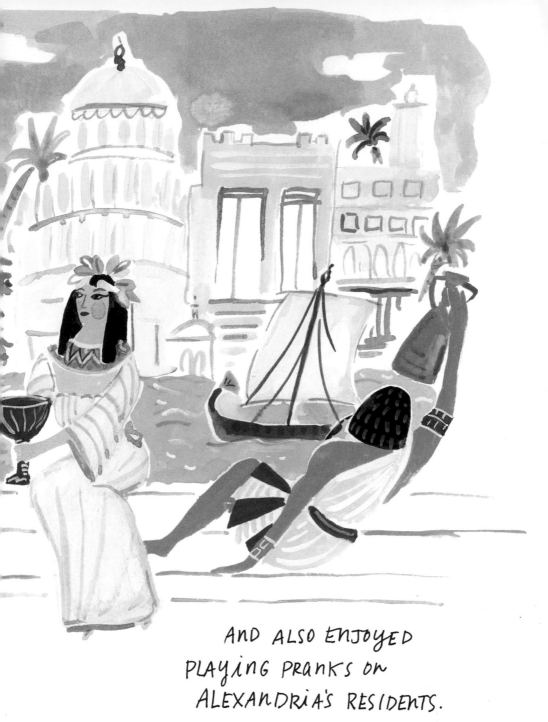

AND ALSO ENJOYED
PLAYING PRANKS ON
ALEXANDRIA'S RESIDENTS.

BOUDICA
c. 27-61 CE
QUEEN OF THE ICENI

Celtic queen Boudica assumed control of the Iceni tribe after the death of her husband, King Prasutagus, who ruled on behalf of Rome. Prasutagus decided to bequeath half his kingdom to his young daughters, but this show of autonomy incensed Roman leaders, who expected the kingdom to return to Rome upon his death. In revenge, Roman soldiers plundered Iceni lands and exacted violent revenge on the royal family. Boudica demanded vengeance, and an enraged Iceni people, along with neighboring tribes, rallied around the Iron Age queen to join her revolt against Rome in about 61 CE, which nearly drove the Romans out of Britain for good.

Boudica's forces burned to ashes three of Roman Britain's largest settlements—including London. But at the final stand (the exact location is unknown) the Romans defeated Boudica's army and effectively quashed the rebellion. Boudica and her daughters died, either by poison or during battle.

The heroism of Boudica, whose name comes from the Celtic word *bouda*, or "victory," appeared lost to the ages until the Renaissance, when her story experienced a rebirth. Boudica's power, courage, maternal devotion, and unflinching fight for her native land were often invoked during the periods of both Elizabeth I and Victoria, when English identity, patriotism, and admiration of powerful female rule flew high.

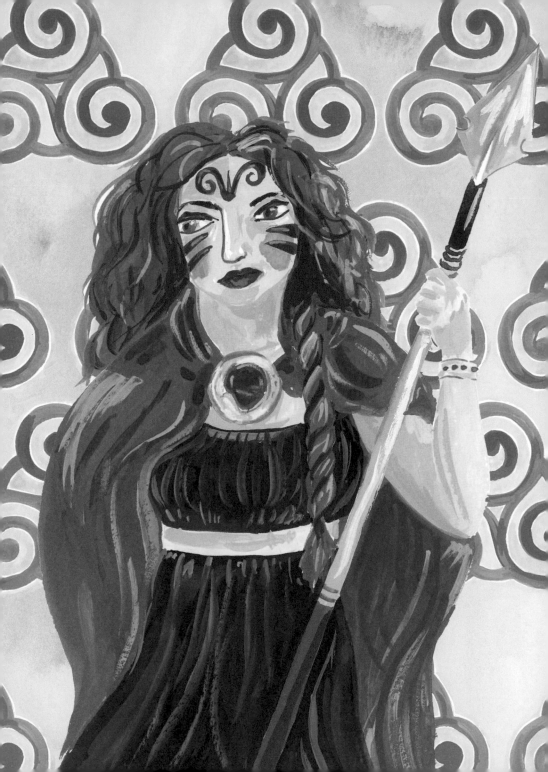

THE ICENI KINGDOM WAS
PROSPEROUS UNDER
KING PRASUTAGUS'S REIGN.

A LARGE PORTION OF ICENI
LAND WAS LOCATED IN
PRESENT-DAY NORFOLK,
A COUNTY IN
EASTERN ENGLAND.

ROMAN SOLDIERS FLOGGED BOUDICA AND SEXUALLY ASSAULTED HER DAUGHTERS. ICENI CHIEFS WERE STRIPPED OF THEIR ANCESTRAL LANDS AND THE KING'S RELATIVES WERE ENSLAVED.

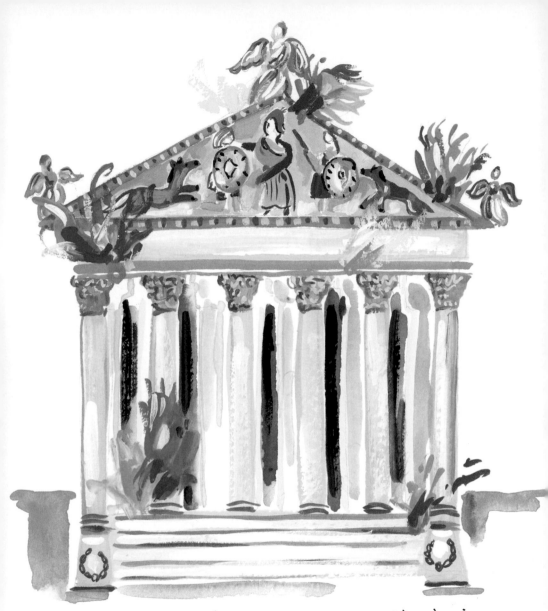

ROMAN CITIZENS OF COLCHESTER HID INSIDE
THE TEMPLE OF CLAUDIUS, BUT BOUDICAN
FORCES BROKE THROUGH BY SCALING THE WALLS
AND SMASHING THE TILE ROOF.

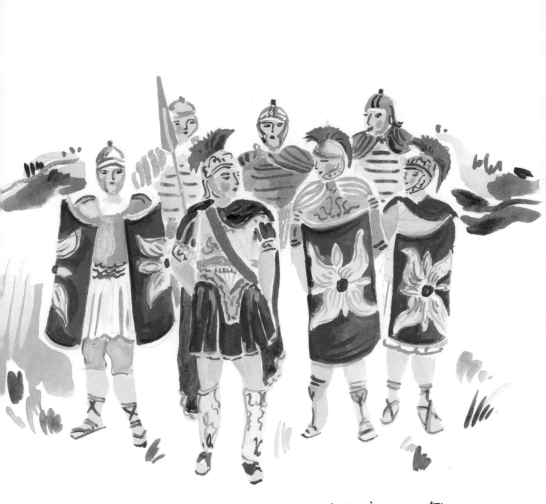

WHEN BOUDICA'S FORCES TRIED TO FLEE the FINAL BATTLE, THEY WERE TRAPPED BY THEIR FAMILY MEMBERS' WAGONS STATIONED AROUND the EDGE OF the BATTLEFIELD.

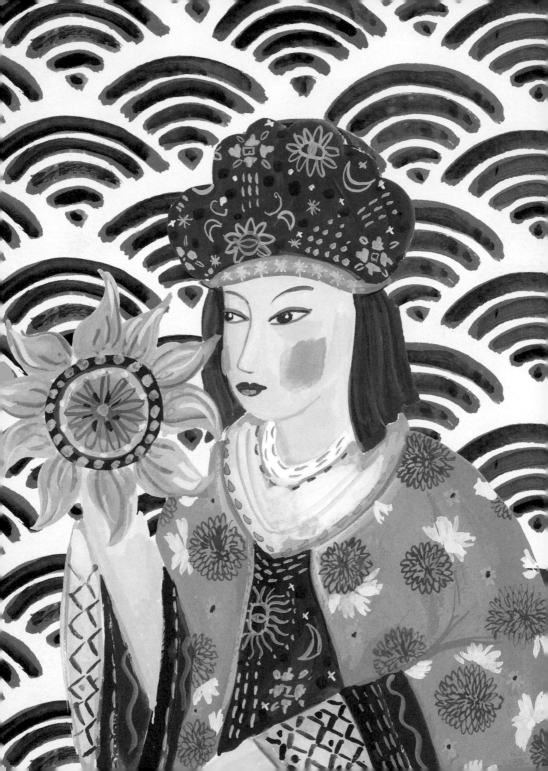

HiMiKO

c. 183-248 CE

QUEEN OF THE YAMATAI

Sorcery, witchcraft, and magic—such were the dark powers ascribed to ancient Japanese ruler Himiko, who presided over the Yamatai realm and neighboring principalities in the third century CE. Much of what is known about her and her kingdom comes from early Chinese historical accounts, specifically the *Hou Hanshu* and the *Wei zhi*, a section of a larger document that contains information from Chinese envoys on the people and kingdoms of early Japan.

The histories describe Himiko as an unmarried shaman-queen who practiced magic and sorcery and ruled over the powerful kingdom of Yamatai and nearly thirty other chiefdoms. Portrayed as a mysterious and reclusive figure, Himiko came to power after a decades-long period of war and strife under a male ruler. She was rarely seen and lived inside a closely guarded palace with many female servants and just one man. Her younger brother aided her in ruling the kingdom.

Himiko engaged in diplomacy with the Chinese Wei kingdom. In return, Himiko received official recognition of her position as queen of Japan, as well as gifts of brocades, silks and wools, gold, swords, pearls, cinnabar, and bronze mirrors. Chinese historians report that Himiko died around the age of sixty-five and was buried in a large tomb with a sacrifice of a hundred slaves. A period of mass instability followed her death. A male ruler briefly tried to reign, but he was rejected outright by the people. Finally, a female relative of Himiko's—a thirteen-year-old girl named Iyo—ascended to the throne and was accepted by the populace.

HIMIKO WAS SAID BY CHINESE HISTORIANS TO BE SKILLED IN SORCERY AND TO HAVE BEWITCHED THE PEOPLE IN HER DOMAIN.

REPORTEDLY, HIMIKO WAS SURROUNDED
BY A THOUSAND WOMEN
ATTENDANTS AND A SINGLE MAN, WHO BROUGHT
HER FOOD AND DRINK AND SERVED AS
HER MESSENGER.

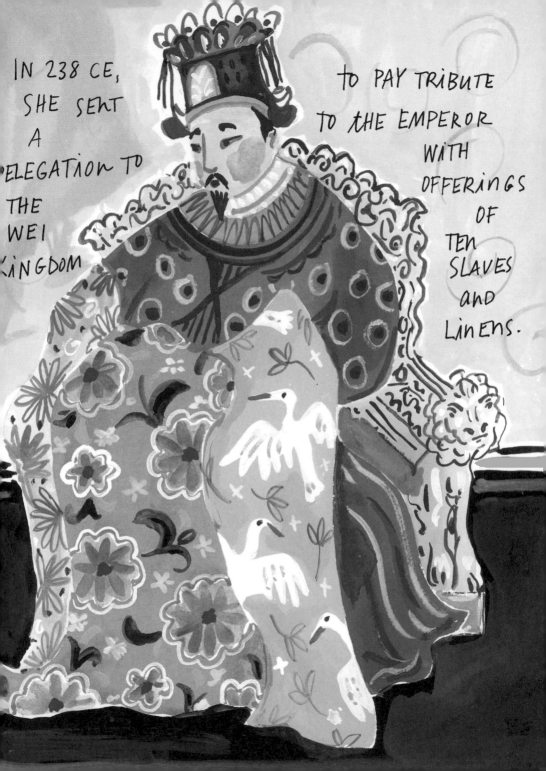

IN 238 CE, SHE SENT A DELEGATION TO THE WEI KINGDOM TO PAY TRIBUTE TO THE EMPEROR WITH OFFERINGS OF TEN SLAVES AND LINENS.

ZENOBIA

c. 241 – c. 274 CE

QUEEN OF PALMYRA

The ancient Syrian city of Palmyra, a wealthy desert oasis fabled for its lush palm groves, was governed by Zenobia in the third century CE. Born to an elite family and widely admired for her hunting and battle skills, she became queen after the assassination of her husband, Odaenathus, and ruled the Roman-held city as regent for her young son.

During her brief but powerful reign, she defied Rome by expanding her kingdom westward, first securing Syrian-Arabian territories, and then vanquishing Roman opposition forces to win control of Egypt, actions that Zenobia hoped would prove she was a capable partner of the empire. Instead, Roman emperor Aurelian took off in hot pursuit, determined to take Zenobia down by force. Meanwhile, she also attempted to conquer Asia Minor, but failed mightily.

As queen, one of Zenobia's early endeavors was to position Palmyra as a great center of cultural and intellectual sophistication, rivaling Alexandria. Indeed, her greatest influence was Cleopatra—Zenobia even claimed a purported shared ancestry—and Cleopatra's erudition, enterprise, and acumen profoundly inspired Zenobia. But unlike Cleopatra, Zenobia is said to have taken pride in her chastity, only sleeping with her husband once a month, and only to bring forth an heir.

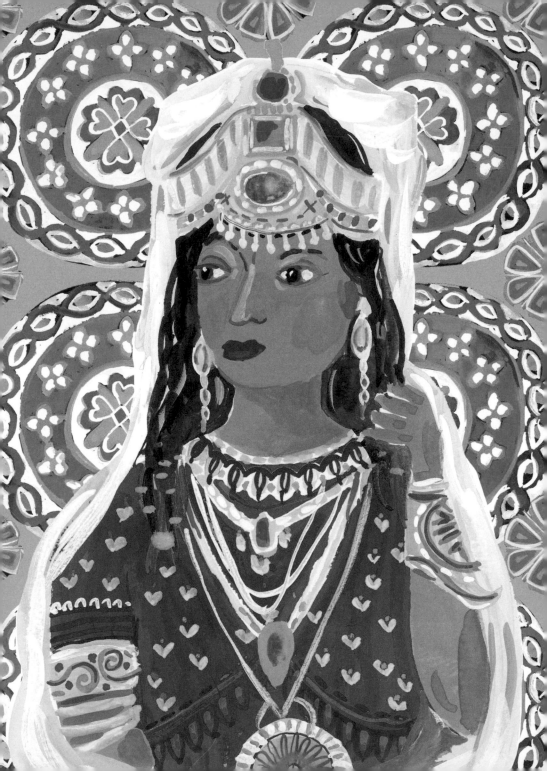

PALMYRA WAS AN IMPORTANT HUB ON
INTERNATIONAL TRADING ROUTES. VAST and
VARIED GOODS - LIKE SALT, MUSLIN, and
PRECIOUS GEMS - FLOWED THROUGH the CITY.

AFTER CONQUERING EGYPT, ZENOBIA'S COINAGE FEATURED HER NAME and HER SON'S. BUT BORE NO MENTION OF EMPEROR AURELIAN'S NAME— AN ACT THAT FURTHER ENRAGED ROME.

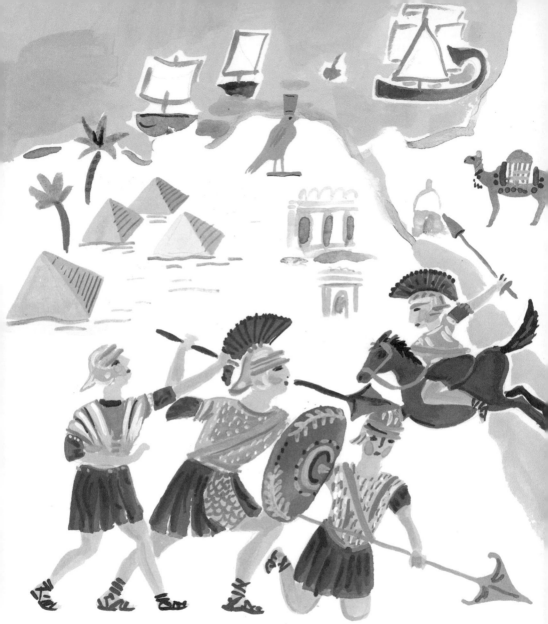

ZENOBIA'S FORCES INVADED EGYPT WITH
70,000 TROOPS AND SCORED THEIR
FINAL VICTORY DURING A BATTLE
AT BABYLON, A ROMAN FORTRESS CITY.

THE DEFEATED QUEEN BECAME A ROMAN CAPTIVE and WAS PARADED in FRONT OF AURELIAN'S CHARIOT FETTERED BY GOLDEN SHACKLES AT HER HANDS and FEET.

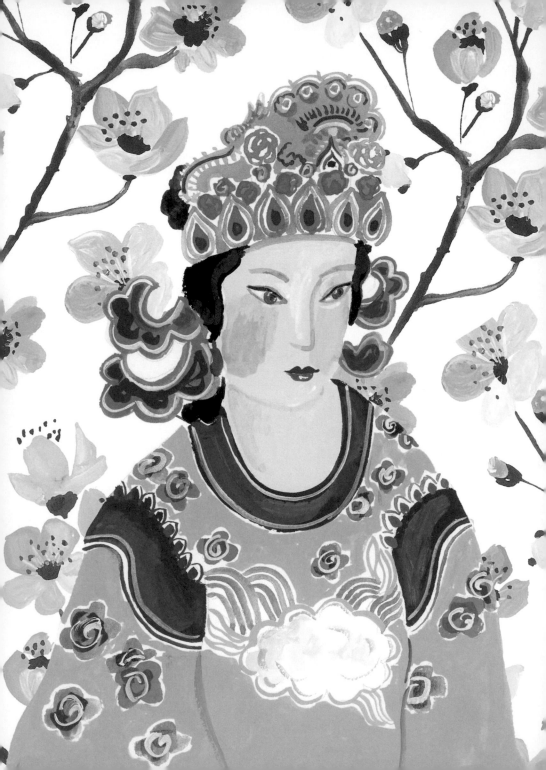

WU ZETIAN

625 - 705 CE
EMPRESS OF CHINA

The unprecedented but highly scandalous reign of Wu Zetian remains a riveting chapter of China's imperial past. The only woman sovereign in three thousand years of Chinese history, Wu ruled China during the Tang Dynasty in the seventh century CE. Her extraordinary reign boasted diplomatic, social, and military achievements, but also much controversy: Most notably, she was accused of murdering her own family members, including her own infant daughter, in her quest for ultimate power.

At fourteen years old, Wu joined the imperial palace of Emperor Taizong as a low-ranking concubine. In 655 CE, she married his successor, Emperor Gaozong, and became Empress of China. Over the years, Wu's power and influence soared, and she ruthlessly eliminated her enemies while keeping her supporters close. In 690, she became the sole ruler of her empire and created a new dynasty, the Zhao.

China prospered under Wu's reign, and she proved to be a strong, capable leader. Agriculture and trade along the Silk Road thrived, and she poured money into literature, education, and the arts. Buddhism, a foreign import from India, rose to prominence during her rule, as Wu perceived its teachings as being friendlier toward women than those of the official state religion of Confucianism.

In 705 CE, Wu was buried with Gaozong in a special joint tomb. To this day, it remains unopened—keeping the story of Wu alive forevermore.

WU
TOLD
TAIZONG
SHE COULD
CONQUER LION, A NOTORIOUSLY WILD HORSE,
WITH AN IRON WHIP, AN IRON HAMMER,
AND, IF ALL ELSE FAILED, A DAGGER.

THE GRISLY DEATHS OF HER RIVALS TROUBLED HER AT THE PALACE, so GAOZONG MOVED THE IMPERIAL HEADQUARTERS TWO HUNDRED MILES EAST, FROM CHANG'AN TO LUOYANG.

THE FENGXIAN CAVE,
BUILT FOR WU,
AT LONGMEN
GROTTOS
HOLDS
NINE
BUDDHA
STATUES.

REPORTEDLY
THE
VAIROCANA
BUDDHA
THERE
WAS
CARVED TO
RESEMBLE
THE EMPRESS.

WU SPONSORED THE WRITING AND PUBLICATION OF SEVERAL BIOGRAPHIES OF FAMOUS WOMEN IN HISTORY, WHICH HELPED NORMALIZE FEMALE RULE.

LADY SIX SKY

7th-8th Century CE

MAYA QUEEN OF NARANJO

Lady Six Sky was a Maya royal princess and daughter of King B'alaj Chan K'awiil, ruler of Dos Pilas. In 682 CE, she was sent by her father to Naranjo (located in present-day Guatemala), where the local royal bloodline had been destroyed when that lineage was conquered by a more powerful polity. Lady Six Sky was tasked with breathing new life into Naranjo and reestablishing a royal dynasty. Though she was never formally crowned as Naranjo's queen, she governed for about a decade, until her son, K'ak' Tiliw Chan Chaak, ascended the throne at the age of five, and appears to have acted as his regent for many more years during his childhood.

Unlike other Maya women rulers, Lady Six Sky was in the unique position of having stone monuments erected during her lifetime, which recorded her successes and showcased the significant power she held. Two depictions portray her standing on top of bound captives in the style of a warrior king, while another pictures Lady Six Sky's accession to the throne.

While her son was king, she also engaged in diplomacy and orchestrated victorious military campaigns against neighboring polities, which expanded Naranjo's territory, and her skillful leadership positioned Naranjo as a center of power during the golden age of Maya civilization.

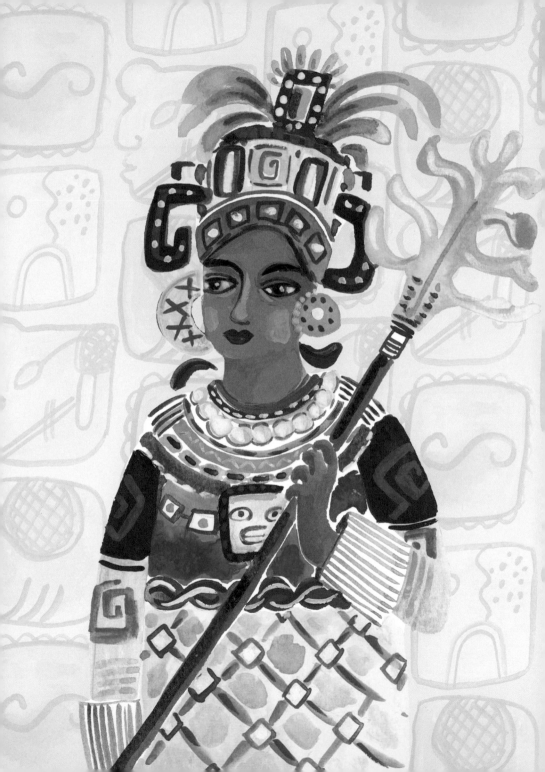

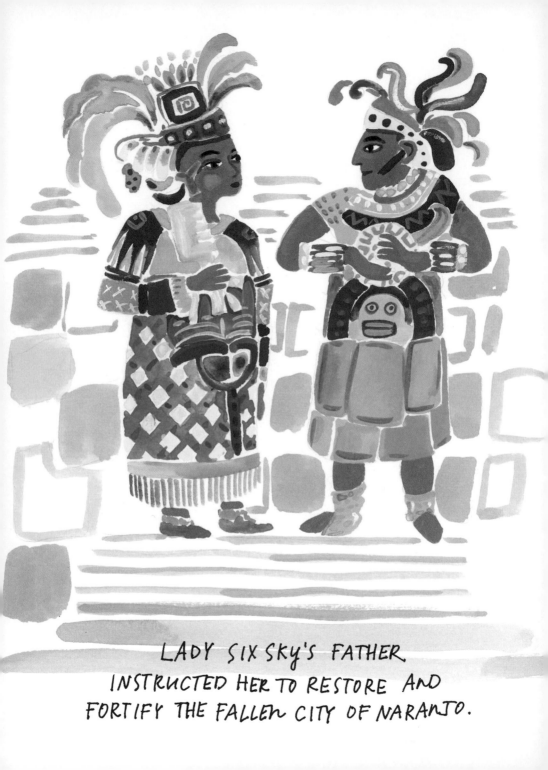

LADY SIX SKY'S FATHER
INSTRUCTED HER TO RESTORE AND
FORTIFY THE FALLEN CITY OF NARANJO.

AS A RULER, SHE LEGITIMIZED HER REIGN BY PERFORMING IMPORTANT CALENDRICAL RITUALS TYPICAL OF A KING.

LADY SIX SKY OVERSAW EIGHT MILITARY

OPERATIONS AGAINST NEIGHBORING CITIES.

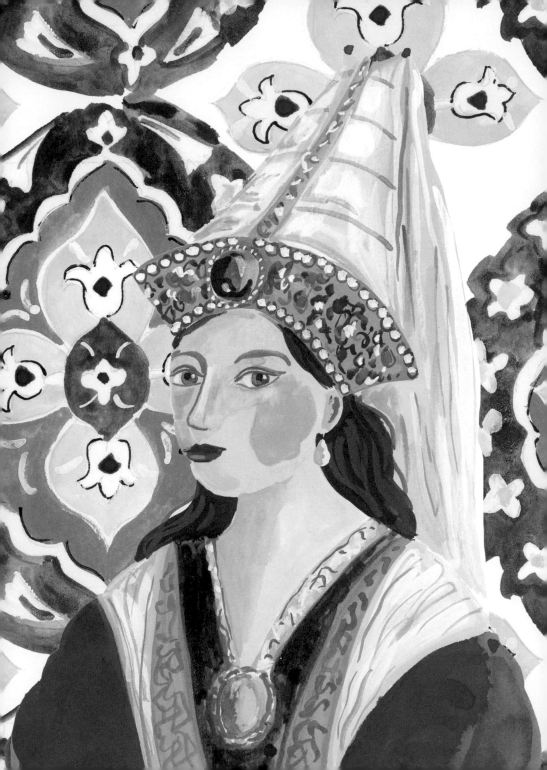

ROXELANA

c. 1503-1558 CE

QUEEN OF THE OTTOMAN EMPIRE

Roxelana first entered the Ottoman Empire as a Russian slave and then became a concubine in the imperial harem of Suleyman I ("the Magnificent"). After their first meeting, Suleyman was instantly, irreversibly smitten. His devotion positioned Roxelana—whose playful nature won her the nickname Hurrem, which means "laughing" or "joyful"—in a place of unprecedented power and influence that would have a lasting impact on the legacy of royal women of the empire.

Intelligent, politically savvy, and a quick study, Roxelana soon grasped the ways of the harem as well as those of Suleyman, who relied on the counsel of his inner circle, especially his mother. Roxelana therefore became his most trusted confidante and informant, advising him in political and diplomatic matters and gathering and passing on intelligence.

Because she was a slave and concubine, her controversial marriage to Suleyman in 1536 stunned the public, and the world. Together they raised six children (a shocking violation of the empire's "one concubine, one son" rule), of whom five were male, elevating Roxelana's status above that of her primary harem rival's, whose son had previously been considered Suleyman's heir.

When Roxelana became a sultana, she acquired the title Haseki Sultan, or "favorite," and moved out of the harem and into lavish quarters within Suleyman's own palace. This was yet another tradition-shattering move that laid the groundwork for the imperial harem's eventual transformation into a legitimate political body within the Ottoman government.

CRIMEAN TATAR SLAVERS SNATCHED
FIFTEEN-YEAR-OLD ROXELANA
DURING A RAID.
SHIPPED TO A SLAVE MARKET
IN ISTANBUL, SHE WAS
PURCHASED AS A GIFT
FOR THE SULTAN.

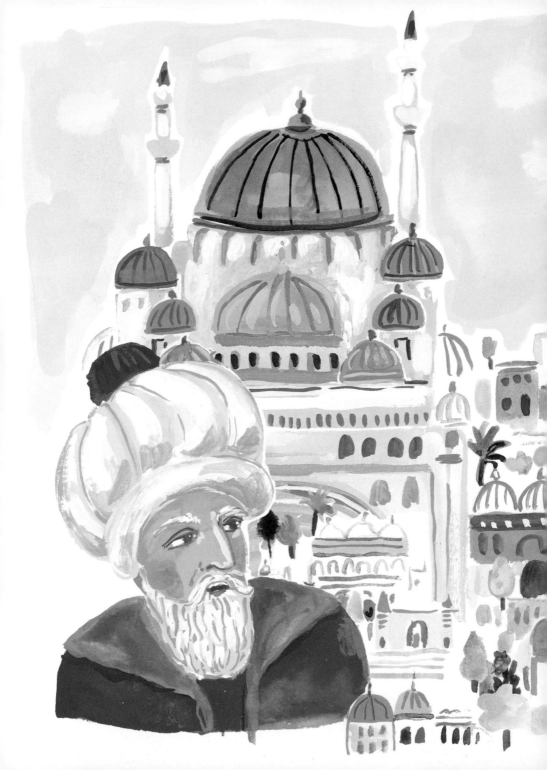

ROXELANA COMMISSIONED SEVERAL BUILDINGS FOR THE PUBLIC, INCLUDING MOSQUES, HOSPITALS, AND SCHOOLS. SHE ALSO BUILT THE HASEKI SULTAN COMPLEX TO SERVE THE NEEDS OF WOMEN.

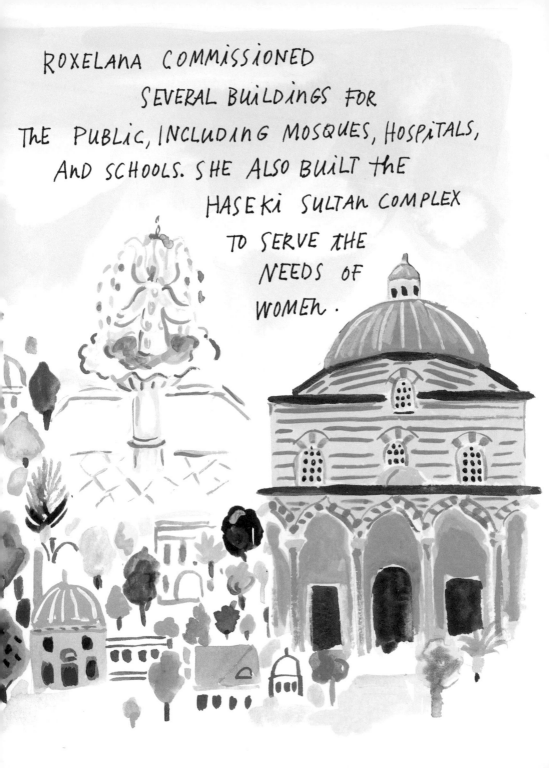

ELIZABETH I

1533 - 1603 CE

QUEEN OF ENGLAND

England's most famous royal, Elizabeth I, wasn't always destined for the throne. Born to Henry VIII and Anne Boleyn, she was third in line for the crown. She became Queen of England at the age of twenty-five, after the deaths of her younger brother Edward and her older half-sister Mary.

England was politically and financially weak when Elizabeth was crowned. The threat of Spanish and French aggression loomed, and religious dissent divided the populace. Moreover, sixteenth-century English society was deeply patriarchal, and women were thought to be inferior to men. Elizabeth's queenship, therefore, required a deft combination of clever maneuvering, composure, discretion, and the ability to use powerful language to craft her identity as a female ruler in a traditionally masculine role.

She was immensely popular. Although she entertained several proposals, she never married, and became famous for her virginity. As she aged, Elizabeth encouraged her portrayal as the Virgin Queen married to her country.

Her rule—the Elizabethan era—brought peace and stability back to England. She restored Protestantism as England's official religion, established the country as a great world power, and defended her throne against countless threats. The later part of Elizabeth's reign is considered the golden age of English history, a period of international expansion and exploration, and a time when music, poetry, literature, and drama flourished.

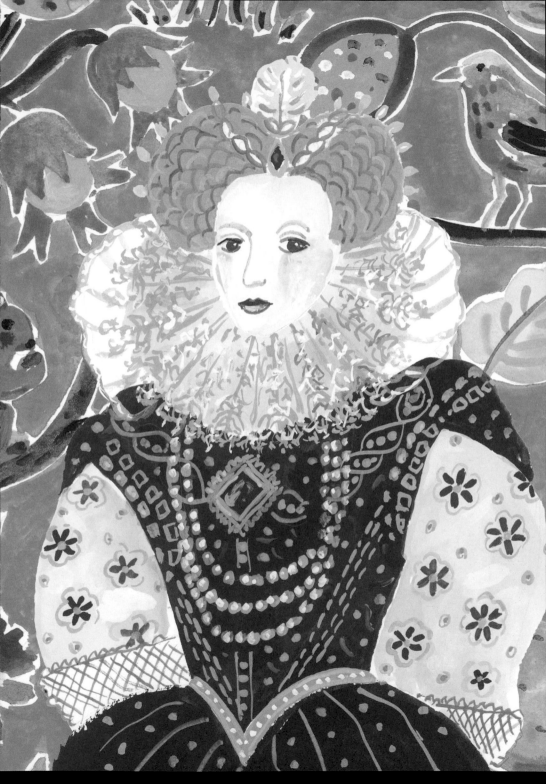

ENGLAND'S DEFEAT OF
THE MIGHTY SPANISH ARMADA
in 1588 is CONSIDERED
ONE OF its GREATEST
MILITARY ACHIEVEMENTS.

REPORTEDLY, ELIZABETH ASKED SHAKESPEARE FOR A DRAMA FEATURING THE CHARACTER OF SIR JOHN FALSTAFF FALLING IN LOVE — SO SHAKESPEARE PENNED THE MERRY WIVES OF WINDSOR.

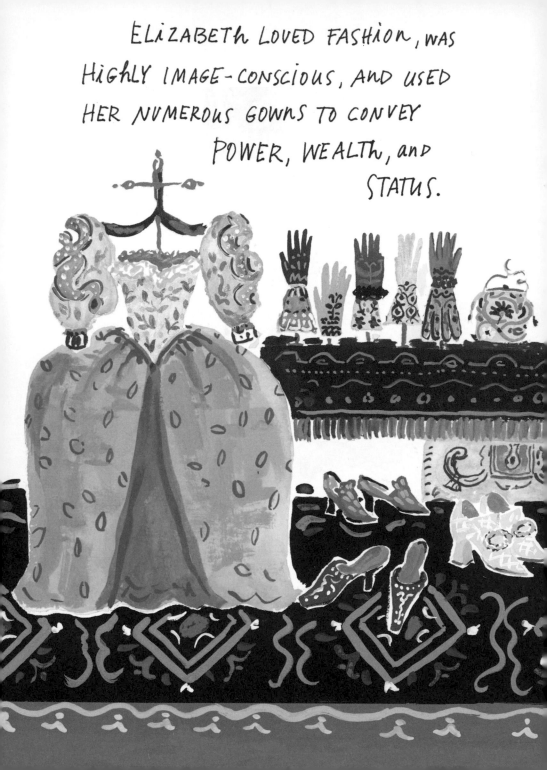

DRESSING AND UNDRESSING TOOK FOUR HOURS EACH DAY.

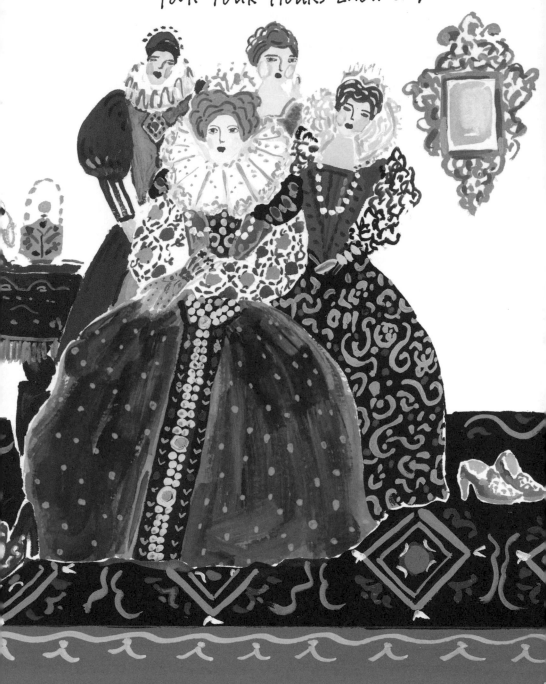

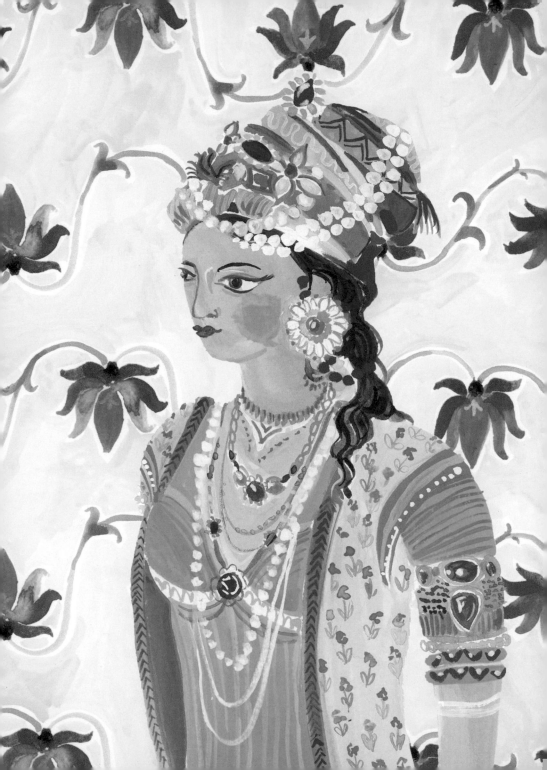

NUR JAHAN
1577-1645 CE
EMPRESS OF MUGHAL INDIA

Born into Persian nobility and named Mehrunnissa, "sun among women," Nur Jahan grew up in India alongside noble families of the Mughal court. Following the death of her first husband, she became a lady-in-waiting to Ruquaiya Sultan Begum, Emperor Jahangir's stepmother.

In 1611, Mehrunnissa met Jahangir, who was instantly captivated by her charisma, exquisite beauty, and keen intellect; within two months they wed, and thirty-four-year-old Mehrunnissa became his chief, last, and most beloved wife—and Empress of Mughal India. Jahangir later named her Nur Jahan, "light of the world."

Nur Jahan held absolute sway over the emperor's heart—and his empire. She governed the vast imperial *zenana*, home to hundreds of women, including wives and concubines. She minted coins in her name and engaged in international diplomacy.

In all, Nur Jahan wielded exceptional authority and influence, giving her near-complete power, but this also bred resentment among Jahangir's inner circle: Army commander Mahabat Khan staged a failed coup in 1626 against the emperor, while Jahangir's son, Prince Khurram (the future emperor Shah Jahan, who built the Taj Mahal), marched against the pair in 1622, only to be put down by Mahabat Khan's forces.

NUR JAHAN MET JAHANGIR DURING THE PALACE'S NOROUZ (PERSIAN NEW YEAR) FESTIVITIES.

WHILE HUNTING,
NUR JAHAN KILLED
A TIGER
FROM BEHIND THE
CURTAINS OF HER
HOWDAH (CARRIAGE)
WITH A
SINGLE
SHOT.

DESIGNING AND LAYING OUT GARDENS BECAME
AN IMPORTANT IMPERIAL OBJECTIVE UNDER
NUR JAHAN'S REIGN, WHICH GAVE ROYAL WOMEN
THE FREEDOM TO TRAVEL AT THEIR LEISURE.

ROYAL WOMEN OFTEN SPENT THEIR
WEALTH IN TRADE, INCLUDING
BUYING SHIPS AND TRANSPORTING
CARGO.

CHRÍSTINA OF SWEDEN

1626-1689 CE

QUEEN OF SWEDEN

Prior to her staggering decision to abdicate the throne, abandon Lutheranism, and become a Roman Catholic, seventeenth-century queen Christina ruled Sweden for almost a decade. She gave up her crown in 1654 and headed straight for Rome. Despite the city's religious and cultural appeal, Christina missed the power, income, and prestige of being queen. She tried, but failed, to gain the crown of Naples, Poland, and even tried to regain that of Sweden.

Christina became queen-elect of Sweden just before she turned six, the result of her father's untimely death in the Thirty Years' War. Until she came of age, a regency of five men ruled on her behalf. She was formally crowned at eighteen. Although the world of governing would prove to hold little interest while she was queen, Christina had a quick, agile mind, and developed in childhood a keen love of learning. In Rome, she lived in the Palazzo Riario—now the Corsini—that housed her extensive collection of paintings. Christina's lavish patronage of art, music, and opera was well known.

Her masculine qualities were also widely observed. She had a particular disdain for anything too feminine; she walked like a man, had a penchant for coarse talk, and spoke in a gruff voice. Marriage, too, was forever out of the question for Christina, whose sexuality, friendships with men and women, and androgynous appearance were always a source of speculation, then and now.

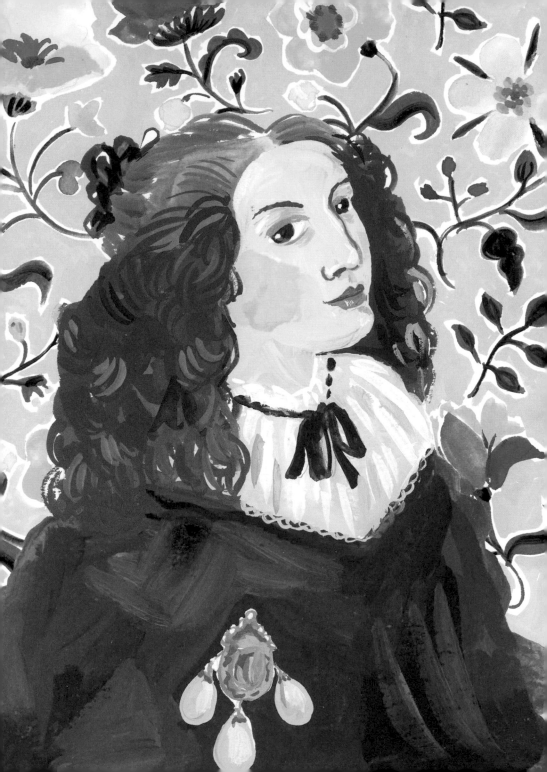

King Gustav II Adolf ensured Christina received the education of a prince. She fenced, hunted and excelled in philosophy, languages, history, religion, politics, and statecraft.

CHRISTINA ADMIRED CATHOLICISM'S
APPRECIATION OF CELIBACY

AND WAS
QUITE
TAKEN BY
BY
ROME'S
INTELLECTUAL
AND
ARTISTIC
VIBRANCY.

SHE
KNEW HER
HAPPINESS
LAY NO
MORE
IN
SWEDEN.

SHE LEFT FOR ROME
DISGUISED AS
COUNT DOHNA, a knight

AND WAS
RECEIVED WITH
GREAT
POMP BY
POPE
ALEXANDER
VII.

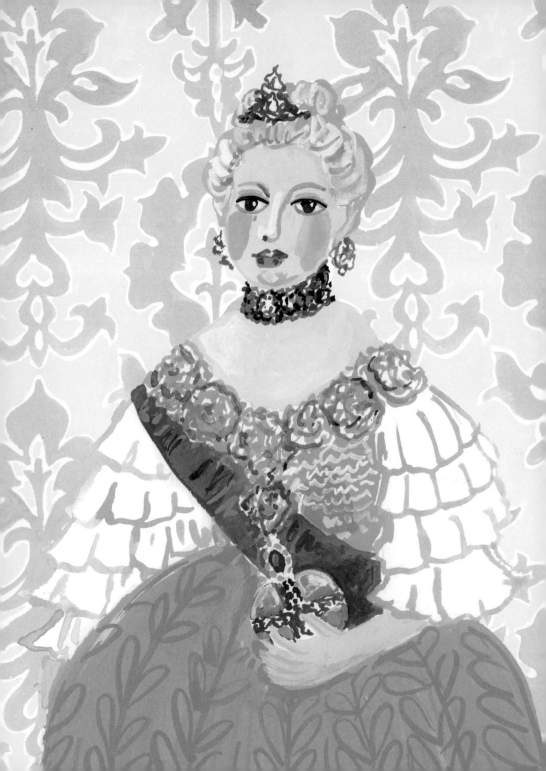

CATHERINE the GREAT
1729-1796 CE
EMPRESS OF RUSSIA

The reign of Russia's Catherine the Great was the longest the country had ever seen, but the empress was not Russian by birth. She was born Sophie von Anhalt-Zerbst, the daughter of a Prussian prince. When she was fifteen she married Peter III, grandson of Peter the Great and heir to the Russian throne. Catherine wholly embraced her new identity, learning Russian and converting to the Russian Orthodox religion.

But her marriage was a failure: Peter was an alcoholic who showed little interest in his wife, preferring to hole up in his room and play with toy soldiers. The couple had trouble consummating their marriage, though, after seven years, they eventually did. Around that time, Catherine began her love affairs; her need for love was as great as her ambition. Peter eventually became king, but his six-month rule proved disastrous, and in 1762, Catherine participated in a military coup to unseat him and claim his throne for herself.

As empress, she significantly extended Russia's borders, revamped its educational system, and cultivated a glittering court on par with its European counterparts. Intellectually curious and viewing herself as an enlightened ruler, she actively corresponded with Voltaire and Diderot. But she failed to carry out her plan to free Russia's serfs, leaving them worse off than before—her enlightenment had its limits.

CATHERINE DONNED A SYMBOLIC MILITARY UNIFORM AND RODE WITH HER ARMY REGIMENTS TO OVERTHROW PETER IN A COUP HEADED BY GRIGORY ORLOV, HER LOVER.

POTEMKIN

ORLOV

CATHERINE NEVER MARRIED AGAIN BUT TOOK MANY LOVERS,

WHO OFTEN RECEIVED PLUM POSITIONS AND LAVISH GIFTS.

ORLOV, A FAVORITE, RECEIVED A PALACE IN ST. PETERSBURG.

SHUVALOV

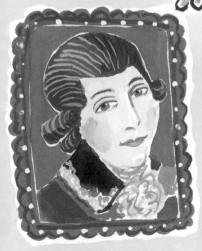

LANSKOY

RIMSKY-KORSAKOV

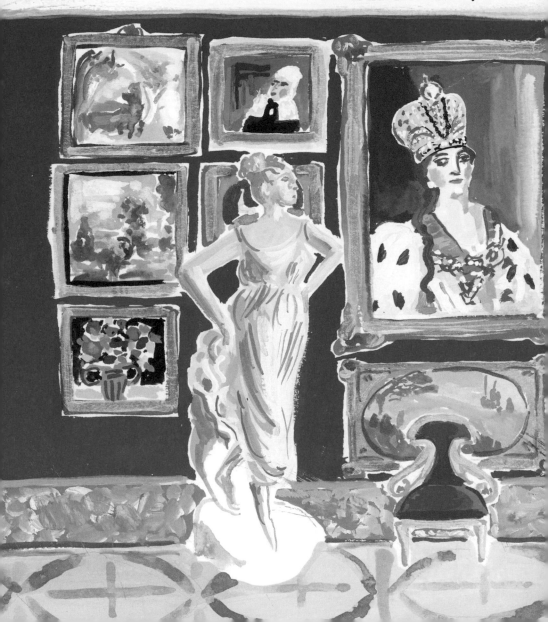

An Enthusiastic Patron of the Arts, Catherine founded the Hermitage Museum in St. Petersburg,

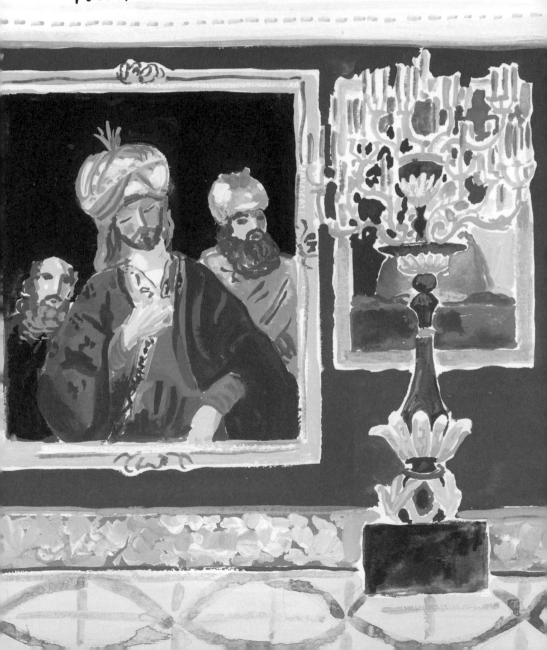

ALiQUiPPA

c. 17th Century – 1754 CE

QUEEN OF THE SENECA

Possessing an intriguing mix of power and prestige, eighteenth-century queen Aliquippa was an influential leader of the Seneca tribe who lived in areas of Pennsylvania, including along three rivers (the Ohio, the Monongahela, and the Allegheny) near the Pittsburgh region. Her cachet in the area was well known, prompting colonial representatives and military officials to make sure they remained in her good graces. She was faithfully pro-British and served as a significant source of support leading up to the French and Indian War (1754–1763), in which Britain and France battled for control over North American territory.

Details of her life are scant, and even her birth year is unclear—historical sources estimate she was born in the late 1600s. Diary entries kept by diplomats, military officers, and traders in the area depict Aliquippa as a person of high authority who could request and receive supplies, and who had the power to deny entry to a French military officer who was there to claim the area for France.

The most notable visitor to her village was a young George Washington, whom she saw again at the 1754 Battle of Fort Necessity. He later held a ceremony honoring her loyalty and service to Britain.

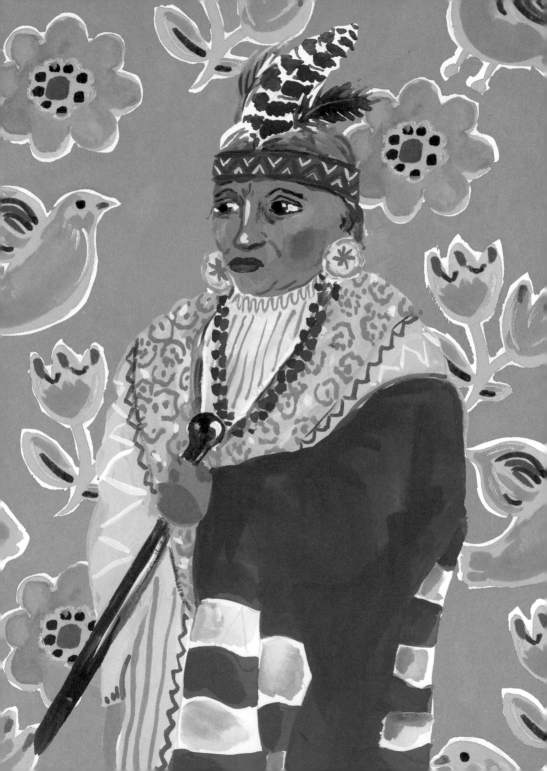

In 1701,
QUEEN ALIQUIPPA, with
HER HUSBAND and SON, WENT TO DELAWARE
TO VISIT WILLIAM PENN, FOUNDER OF PENNSYLVANIA,
BEFORE HE SAILED BACK TO ENGLAND.

In 1753, GEORGE WASHINGTON PRESENTED ALIQUIPPA WITH A MATCH COAT (A LARGE, LOOSE CLOTH WRAPPED AROUND THE UPPER BODY) AND A BOTTLE OF RUM.

SHE FOUNDED
ALIQUIPPA'S
TOWN,
WHICH WAS
LOCATED
ON THE
OHIO RIVER.

ALIQUIPPA
REQUESTED
AND RECEIVED VALUABLE GIFTS FROM HER
VISITORS, INCLUDING WEAPONS, CLOTHING,
AND COOKING VESSELS.

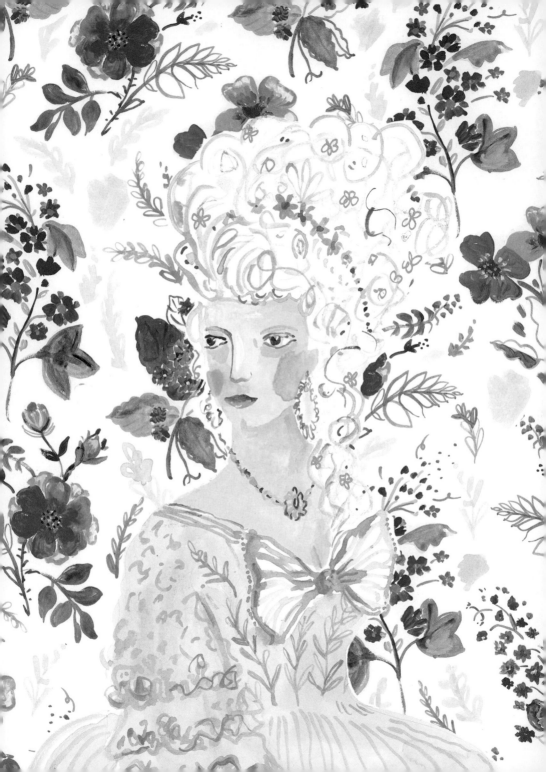

MARIE ANTOINETTE

1755-1793 CE
QUEEN OF FRANCE

The pleasure-seeking, extravagant, ultimately catastrophic reign of Marie Antoinette got its start in 1770, when the fourteen-year-old princess married Louis XVI and four years later became Queen of France. Although initially popular with the people, her lavish spending—despite the country's soaring debt—and seeming apathy toward the poverty-stricken populace fueled their desire to see the monarchy abolished and the royal family brought to justice.

Austrian-born Marie Antoinette's marriage was a bargaining chip between rivals Austria and France. Her early years at court were lonely; her husband was timid, and she often felt homesick. It took seven years for the couple to consummate their marriage. Terrified of boredom, Marie Antoinette spent exorbitant sums on lavish decor and fashion—she ordered three hundred gowns a year—and passed the time at masked balls and operas.

Fashionable to the hilt, she was famous for her towering hairdos—the pouf—that were sometimes three feet high. Though frivolous and politically inexperienced, she wasn't cruel, and when told the people of France were hungry, she never actually said, "Let them eat cake." In 1789, an angry, violent mob stormed the Bastille, a Parisian prison, triggering the French Revolution. In 1792, the royal family was briefly imprisoned; Louis XVI was later executed. The following year, Marie Antoinette was put on trial and beheaded two days later.

MARIE ANTOINETTE AND LOUIS XVI MARRIED
in A LUXURIOUS CEREMONY in THE PALACE
of VERSAILLES'S ROYAL CHAPEL.

LE PETIT TRIANON WAS A SMALL CHÂTEAU
at VERSAILLES WHERE MARIE ANTOINETTE
GATHERED WITH FRIENDS — AND HER LOVER,
THE SWEDISH COUNT HANS AXEL von FERSEN.

AT THE QUEEN'S HAMLET,
A PASTORAL RETREAT
ALSO ON THE VERSAILLES
ESTATE,

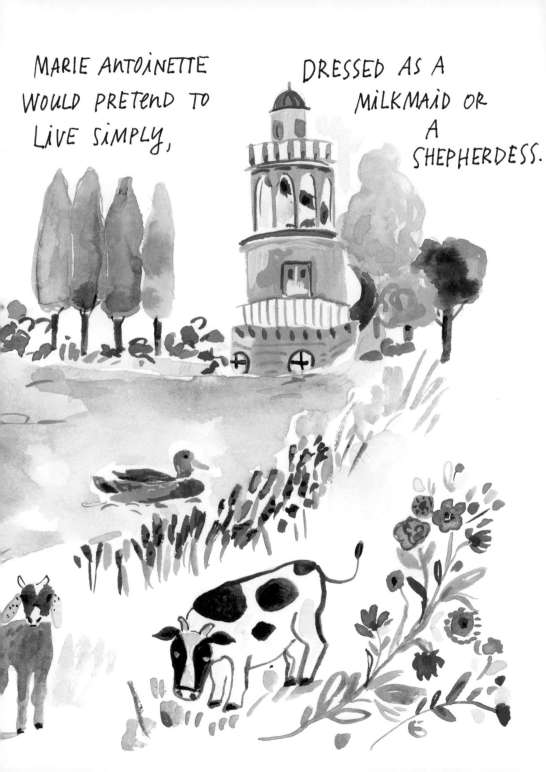

MARIE ANTOINETTE WOULD PRETEND TO LIVE SIMPLY, DRESSED AS A MILKMAID OR A SHEPHERDESS.

LAKSHMI BAI

c. 1830 - 1858 CE
RANI OF JHANSI

Lakshmi Bai was born into an India oppressed by British colonial rule. She was raised in the court of Baji Rao II, a local chief minister, where she spent an unconventional childhood learning to read, write, fence, ride horses, practice martial arts, and possibly shoot guns—skills that would become essential in her later years. In 1842, she married the maharaja Gangadhar Rao of Jhansi, a pro-British but independent princely state in Northern India.

Some years later, Lakshmi Bai gave birth to a son, who died in early infancy. As a result, the maharaja, while on his deathbed, officially adopted a five-year-old relative and pronounced him his heir. The maharaja died the next day, and Lord James Dalhousie, the British governor-general of India, promptly invoked the "Doctrine of Lapse," which did not recognize the adoption and allowed Britain to absorb Jhansi into British territory.

Lakshmi Bai's repeated appeals were rejected, and in 1854 she was ousted from the Jhansi fort. Three years later in Meerut, the Indian Rebellion erupted, the result of long-brewing anger against the injustices of British rule, and rebel-led uprisings raged through the country. According to legend, Lakshmi Bai was killed in battle with a sword in each hand.

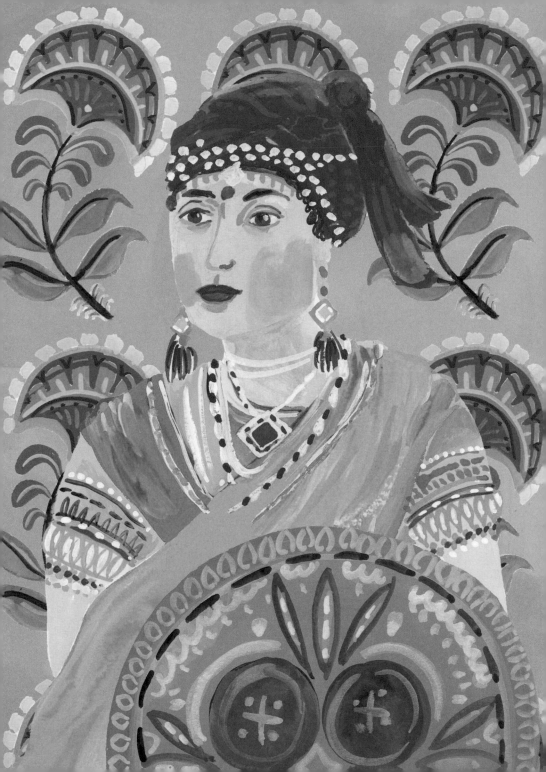

AFTER MARRIAGE, SHE TOOK THE NAME LAKSHMI BAI, IN HONOR OF THE GODDESS LAKSHMI,

THE HINDU DEITY OF WEALTH AND PROSPERITY

THE BRITISH EAST INDIA COMPANY, A PRIVATE COMPANY, RULED AREAS OF INDIA UNTIL 1858,

AFTER WHICH the BRITISH GOVERNMENT, OR THE "BRITISH RAJ," ASSUMED CONTROL.

LAKSHMI BAI RAISED AN ARMY OF 14,000 REBELS, including WOMEN, AND SHORED UP the CITY OF JHANSI'S DEFENSES in PREPARATION FOR the BRITISH ATTACK.

IN DARKNESS, SHE ESCAPED the BESIEGED FORT, her SON STRAPPED To HER BACK, and RODE A HUNDRED MiLES To KALPi, WHERE SHE CONTiNUED the FIGHT.

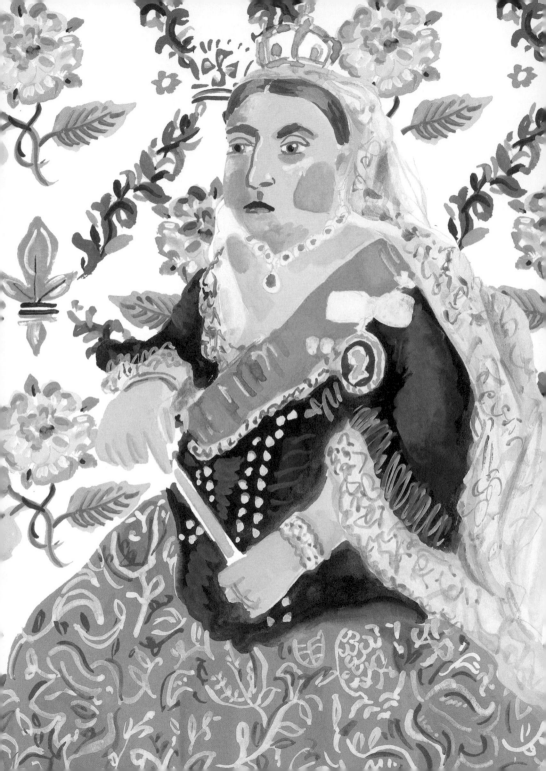

VICTORIA

1819 - 1901 CE

QUEEN OF THE UNITED KINGDOM

England was already a mighty power when Victoria inherited the throne; by the end of her rule, the British Empire would be the biggest the world had ever seen. During her sixty-three years in power, Victoria wielded substantial political influence despite England's position as a constitutional monarchy. Her reign also showed significant social progress: Housing conditions and wages improved, and women were slowly gaining strides in equality (though Victoria herself had no sympathy for that cause).

Her marriage to her first cousin, Prince Albert of Saxe-Coburg and Gotha, is considered one of history's greatest romances. Together they had nine children, who married into royal families across the continent, earning Victoria the nickname "the grandmother of Europe." Albert's death in 1861 sent her spiraling into a deep depression, and for three years afterward she withdrew from the public eye.

In 1853, Victoria delivered her son Leopold, and her use of chloroform—the first pain-relief method available for childbirth—encouraged its wider use. And although the Victorian era is commonly remembered for its strict codes of personal morality and family values, Victoria appreciated sensuality—she loved collecting nude sculptures and paintings, some of which served as birthday gifts for Albert.

A CHORUS OF DRUMS, TRUMPETS, AND CANNONS ERUPTED THE MOMENT VICTORIA WAS CROWNED, AND THE ROOF OF WESTMINSTER ABBE SHOOK FROM THE CELEBRANTS' RAUCOUS CHEERS

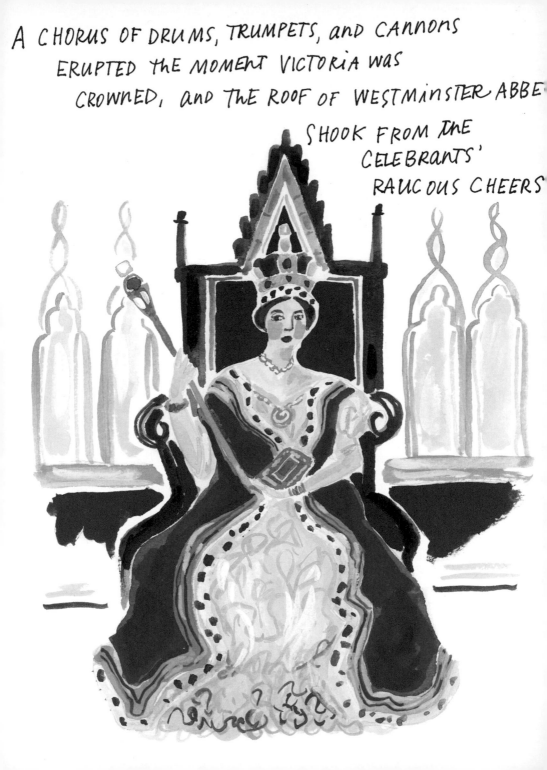

VICTORIA RELIED HEAVILY ON HER HUSBAND ALBERT,
TWO OF HER PRIME MINISTERS, LORD MELBOURNE
AND BENJAMIN DISRAELI, AND LATER, ON HER
TRUSTED SERVANT, ABDUL KARIM.

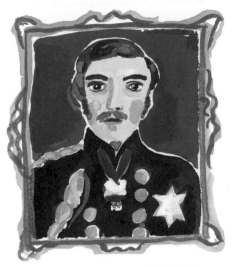

PRINCE ALBERT

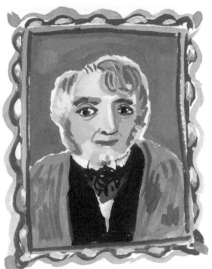

LORD MELBOURNE

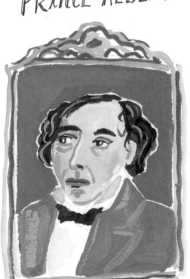

DISRAELI

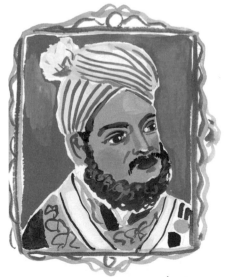

ABDUL KARIM

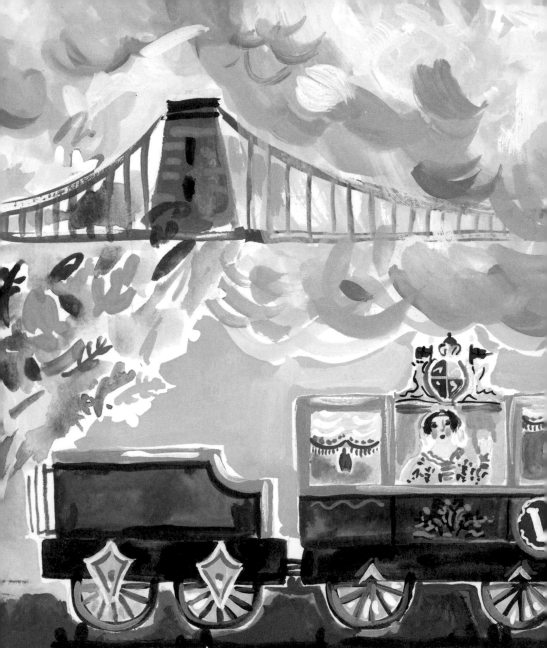

THE VICTORIAN ERA COMPRISED MAJOR
ADVANCES in TRANSPORTATION, SCIENCE,
LITERATURE, and INDUSTRY.

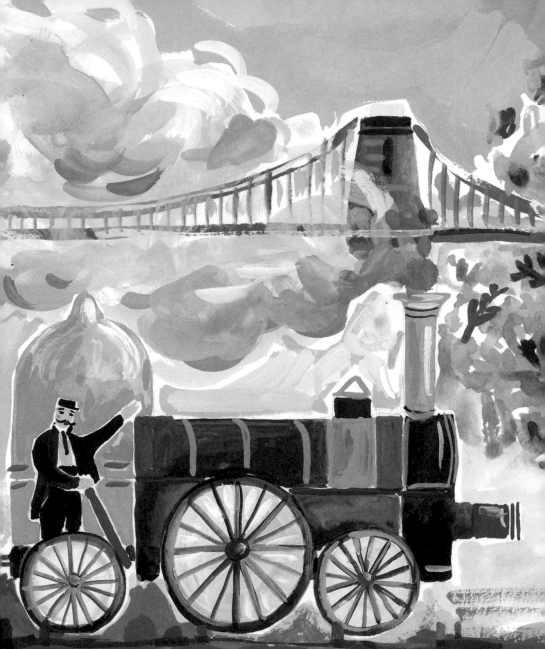

In 1863, London's Metropolitan Railway became the world's first underground rail system.

LILIUOKALANI

1838 - 1917 CE

QUEEN OF HAWAII

Liliuokalani, Hawaii's last queen of paradise, was the islands' final sovereign. Her efforts to restore the monarchy and an independent government of Hawaii—radically weakened during the reign of her brother, King Kalakaua—ultimately led to a government overthrow in 1893. Thus ended the reign of the powerful Kamehameha dynasty, which had ruled Hawaii for more than seventy-five years.

After Kalakaua's death in 1891, Liliuokalani became queen, the first woman to rule Hawaii. A few years prior, in 1887, Kalakaua had been forced, under threat of violence, to sign a constitution largely stripping him of power. This power grab was effected by a group of businessmen, mostly American, who wanted the annexation of Hawaii to the United States.

The 1893 coup against Liliuokalani, led by American and European businessmen and backed by the U.S. military, thwarted her attempts to promulgate a new constitution restoring the Hawaiian monarchy's power. She was deposed, and a provisional government was established. Liliuokalani appealed to President Grover Cleveland, who agreed to reinstate the monarchy, but the provisional government refused. Hawaii became a republic in 1894, with lawyer Sanford Dole as its first president.

A few months later, Liliuokalani's supporters led an uprising to reinstate their queen, but their efforts failed, and Liliuokalani was charged with treason and briefly imprisoned at her home. In 1898, the United States formally annexed Hawaii.

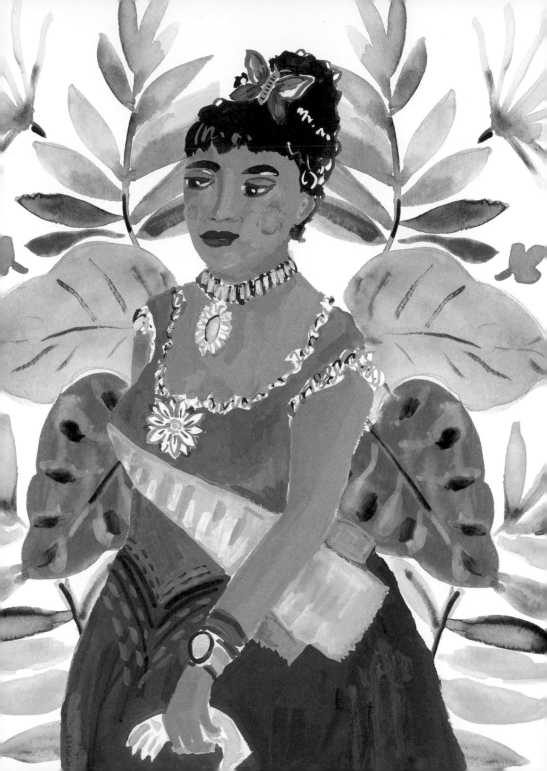

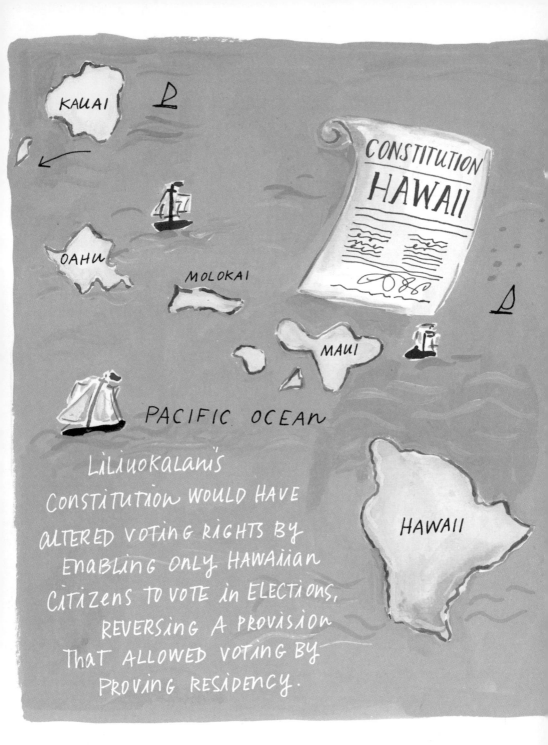

KAUAI

CONSTITUTION
HAWAII

OAHU

MOLOKAI

MAUI

PACIFIC OCEAN

HAWAII

Liliuokalani's Constitution would have altered voting rights by enabling only Hawaiian citizens to vote in elections, reversing a provision that allowed voting by proving residency.

LILIUOKALANI WAS AN ACCOMPLISHED COMPOSER AND WROTE THE FAMOUS "ALOHA OE."

INSPIRED BY AN AFFECTIONATE FAREWELL EMBRACE SHE WITNESSED BETWEEN TWO LOVERS ON OAHU.

DURING HER IMPRISONMENT, LILIUOKALANI
ABDICATED HER THRONE IN EXCHANGE FOR THE
PARDON OF HER LOYALISTS WHO LED THE UPRISING.
SHE WAS FULLY PARDONED IN 1896.

In 1887, Liliuokalani and Queen Kapiolani, who was married to King Kalakaua, traveled to England for Queen Victoria's Golden Jubilee.

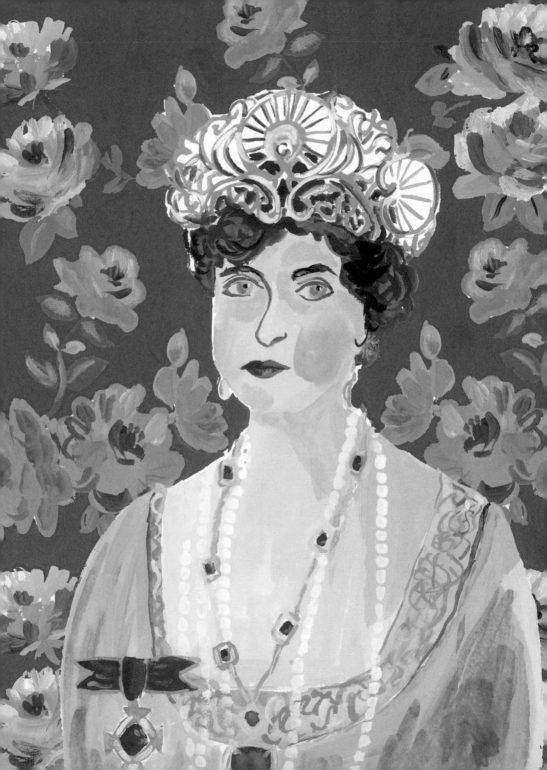

MARIE
1875–1938 CE
QUEEN OF ROMANIA

Queen Marie of Romania was a granddaughter of Queen Victoria. She became queen at the age of eighteen when she married Crown Prince Ferdinand of Romania in 1893. Their wedding was celebrated with three different ceremonies: civil, Catholic, and Protestant. The early years of marriage for Marie and her solemn husband proved difficult, but over time they developed a close bond, although Marie supposedly had several affairs. They had six children; the eldest was Prince Carol, who was heir to the throne.

Marie was charming and beautiful and grew to love Romania, all of which endeared her to the people. As queen, she played an active role in politics and diplomacy, and Ferdinand came to rely on her natural intelligence, which allowed Marie to exert her influence. In 1916, she persuaded Ferdinand to enter World War I and join the Triple Entente, which, in turn, would allow Romania to acquire more territory.

In 1926, Carol renounced his right to succession after a scandalous extramarital affair. After Ferdinand's death in 1927, Marie's five-year-old grandson became king; however, Carol usurped his son's throne three years later.

Marie was a prolific writer and published several books. Her 1934 autobiography, *The Story of My Life*, was well received by critics. In 2015, Marie's heart, which for many years resided at Romania's National History Museum, found its way back home to Pelisor Castle, where she had died in 1938.

MARIE'S
CORONATION
CROWN
WAS
A
SHOWSTOPPING PIECE MADE FROM
TRANSYLVANIAN GOLD AND SO ENCRUSTED WITH RUBIES,
EMERALDS, TURQUOISE, and MOONSTONE THAT iT WEiGHE
FOUR POUNDS.

MARIE
ATTENDED THE PARIS PEACE CONFERENCE
OF 1919 TO CAMPAIGN FOR RECOGNITION OF AN
EXPANDED ROMANIA, WHICH INCLUDED TRANSYLVANIA
AND SEVERAL OTHER TERRITORIES.

In 1926 Marie dedicated the then unfinished Maryhill Museum of Art in Washington State.

She donated art and personal artifacts and released doves at the dedication ceremony.

SOURCES

HATSHEPSUT

Cooney, Kara. *The Woman Who Would Be King*. New York: Crown, 2014.

Tyldesley, Joyce. *Hatchepsut: The Female Pharaoh*. London: Penguin Books Ltd., 1996.

Wilson, Elizabeth B. "The Queen Who Would Be King." Smithsonian.com. https://www.smithsonianmag.com/history/the-queen-who-would-be-king.

ATOSSA

Brosius, Maria. *Women in Ancient Persia*. New York: Oxford University Press, 1996.

Herodotus. *The History of Herodotus*. Translated by G. C. Macaulay. London: MacMillan, 1890. https://www.gutenberg.org/files/2707/2707-h/2707-h.htm.

Mukherjee, Siddhartha. *The Emperor of All Maladies: A Biography of Cancer*. New York: Scribner, 2010.

Sancisi-Weerdenburg, Heleen. "Exit Atossa: Images of Women in Greek Historiography on Persia." In *Images of Women in Antiquity*, edited by Averil Cameron and Amélie Kuhrt. 20-33. Detroit, MI: Wayne State University Press, 1993.

Waters, Matt. *Ancient Persia: A Concise History of the Achaemenid Empire, 550-330 BCE*. New York: Cambridge University Press, 2014.

OLYMPIAS

Carney, Elizabeth. *Olympias: Mother of Alexander the Great*. New York: Routledge, 2006.

Carney, Elizabeth Donnelly. *Women and Monarchy in Macedonia*. Norman: University of Oklahoma Press, 2000.

Mitchell, Lynette G. "The Women of Ruling Families in Archaic and Classical Greece." *Classical Quarterly* 62 (May 2012).1-21.

Plutarch. *Alexander*. Translated by John Dryden. http://classics.mit.edu/Plutarch/alexandr.html.

Wasson, Donald L. "Olympias." Ancienteu.com. https://www.ancient.eu/Olympias.

CLEOPATRA

Crawford, Amy. "Who Was Cleopatra?" Smithsonian.com. https://www.smithsonianmag.com /history/who-was-cleopatra.

Lo, Danica. "Cleopatra Had a Secret Drinking Club." Foodandwine.com. http://www .foodandwine.com/blogs/secret-drinking-club-started-cleopatra-yes-cleopatra.

Preston, Diana. *Cleopatra and Antony: Power, Love, and Politics in the Ancient World.* New York: Walker Publishing Company, 2009.

Schiff, Stacy. *Cleopatra: A Life.* New York: Little, Brown and Company, 2010.

———. "Rehabilitating Cleopatra." Smithsonian.com. https://www.smithsonianmag.com /history/rehabilitating-cleopatra.

Thurman, Judith. "The Cleopatriad: Creating a Queen." Newyorker.com. https://www.newyorker.com/magazine/2010/11/15/the-cleopatriad.

BOUDICA

Collingridge, Vanessa. *Boudica: The Life and Legends of Britain's Legendary Warrior Queen.* New York: Overlook Books, 2006.

Fraser, Antonia. *The Warrior Queens.* New York: Alfred A. Knopf, 1988.

Hingley, Richard, and Christina Unwin. *Boudica: Iron Age Warrior Queen.* London: Hambledon & London, 2005.

HIMIKO

Benard, Elisabeth, and Beverly Moon. *Goddesses Who Rule.* Oxford, UK: Oxford University Press, 2000.

Henshall, Kenneth G. *A History of Japan.* New York: St. Martin's Press, 1999.

Kidder, J. Edward. *Himiko and Japan's Elusive Chiefdom of Yamatai.* Honolulu: University of Hawai'i Press, 2007.

Knapp, Bettina L. *Women in Myth.* New York: State University of New York Press, 1997.

Walker, Hugh Dyson. *East Asia: A New History.* Bloomington, IN: AuthorHouse, 2012.

ZENOBIA

Bryce, Trevor. *Ancient Syria: A Three Thousand Year History*. Oxford, UK: Oxford University Press, 2014.

Fraser, Antonia. *The Warrior Queens*. New York: Alfred A. Knopf, 1988.

Southern, Pat. *Empress Zenobia: Palmyra's Rebel Queen*. London: Continuum, 2008.

WU ZETIAN

Clements, Jonathan. *Wu: The Chinese Empress Who Schemed, Seduced and Murdered Her Way to Become a Living God*. Albert Bridge Books, 2014.

Dash, Mike. "The Demonization of Empress Wu." Smithsonian.com. https://www .smithsonianmag.com/history/the-demonization-of-empress-wu.

Hong Fei, He. "Wu Zetian." In *Notable Women of China: Shang Dynasty to the Early Twentieth Century*, edited by Barbara Bennett Peterson. 191-198. Armonk, NY: M.E. Sharpe, 2000.

LADY SIX SKY

Doyle, James Alan. "Lady Six Sky and the Definition of Ritual Space at Naranjo." *Vanderbilt Undergraduate Research Journal* 1 (May 2005). 1-12.

Eichenseher, Tasha, and Shannon Palus. "The Power and Glory of the Maya Queens." Discovermagazine.com. http://discovermagazine.com/2014/march/16-the-power-and -glory-of-the-maya-queens.

Hardman, Amanda. "Classic Maya Women Rulers in Monumental Art." *Totem: The University of Western Ontario Journal of Anthropology* 14 (June 2011). 1-13.

Sharer, Robert J., with Loa P. Traxler. *The Ancient Maya*. Stanford, CA: Stanford University Press, 2006.

ROXELANA

Peirce, Leslie. *Empress of the East*. New York: Hachette Book Group, 2017.

——. *The Imperial Harem: Women and Sovereignty in the Ottoman Empire*. Oxford, UK: Oxford University Press, 1993.

Reston, James Jr. *Defenders of the Faith*. New York: Penguin Press, 2009.

Yermolenko, Galina. *Roxolana in European Literature, History and Culture*. Farnham, UK: Ashgate Publishing, 2010.

———. "Roxolana: 'The Greatest Empresse of the East.'" *The Muslim World* 95 (January 2005). 231-248.

ELiZABETH I

"Elizabeth I's Royal Wardrobe." Rmg.co.uk. https://www.rmg.co.uk/discover/explore/elizabeth-royal-wardrobe.

Guy, John. *Elizabeth: The Forgotten Years*. New York: Viking, 2016.

Weir, Alison. *The Life of Elizabeth I*. New York: Ballantine Books, 1998.

NUR JAHAN

Findly, Ellison Banks. *Nur Jahan: Empress of Mughal India*. Oxford, UK: Oxford University Press, 1993.

Sessarego, Carrie. "Real Life Romance: Nur Jahan and Jahangir." Smartbitchestrashybooks.com (blog). http://smartbitchestrashybooks.com/2015/11/real-life-romance-nur-jahan-jahangir.

Women and the Garden. "Nur Jahan, Moghul Queen - Part 1." Womenandthegarden.com (blog). http://womenandthegarden.blogspot.com/2013/02/nur-jahan-moghul-queen-part-1.html.

CHRiSTINA ØF SWEDEN

Buckley, Veronica. *Christina of Sweden: The Restless Life of a European Eccentric*. London: Fourth Estate, 2004.

Stolpe, Sven. *Christina of Sweden*. New York: The Macmillan Company, 1996.

CATHERiNE the GREAT

Harris, Carolyn. "When Catherine the Great Invaded the Crimea and Put the Rest of the World on Edge." Smithsonian.com. https://www.smithsonianmag.com/history/when-catherine-great-invaded-crimea-and-put-rest-world-edge-180949969.

Maranzani, Barbara. "8 Things You Didn't Know About Catherine the Great." History.com. http://www.history.com/news/8-things-you-didnt-know-about-catherine-the-great.

Massie, Robert K. *Catherine the Great: Portrait of a Woman*. New York: Random House, 2011.

Rounding, Virginia. *Catherine the Great: Love, Sex, and Power*. New York: St. Martin's Press, 2006.

ALiQUiPPA

Explore PA History. "Queen Aliquippa Historical Marker." ExplorePAhistory.com. http://explorepahistory.com/hmarker.php?markerId=1-A-211.

History of American Women. "Queen Aliquippa: Native American Leader." Womenhistoryblog.com (blog). http://www.womenhistoryblog.com/2008/12/queen-aliquippa.html.

Sipe, C. Hale. *The Indian Chiefs of Pennsylvania*. Butler, PA: The Ziegler Printing Company, 1927.

MARiE ANTOiNETTE

Bashor, Will. *Marie Antoinette's Darkest Days: Prisoner No. 280 in the Conciergerie*. Lanham, MD: Rowman & Littlefield, 2016.

Covington, Richard. "Marie Antoinette." Smithsonian.com. http://www.smithsonianmag.com/history/marie-antoinette.

Farr, Evelyn. *I Love You Madly: Marie-Antoinette and Count Fersen: The Secret Letters*. London: Peter Owen Publishers, 2016.

Lever, Evelyne. *Marie-Antoinette: The Last Queen of France*. New York: Farrar, Straus and Giroux, 2000.

Thurman, Judith. "Dressed for Excess." Newyorker.com. https://www.newyorker.com/magazine/2006/09/25/dressed-for-excess.

LAKSHMI BAI

Banerji, Urvija. "Lakshmibai: The Warrior Queen Who Fought British Rule in India." Atlasobscura.com. https://www.atlasobscura.com/articles/lakshmibai-the-warrior-queen-who-fought-british-rule-in-india.

Fraser, Antonia. *The Warrior Queens*. New York: Alfred A. Knopf, 1988.

Lebra-Chapman, Joyce. *The Rani of Jhansi: A Study of Female Heroism in India*. Honolulu: University of Hawai'i Press, 1986.

VICTORIA

Baird, Julia. *Victoria the Queen: An Intimate Biography of the Woman Who Ruled an Empire.* New York: Random House, 2016.

"The British Empire." DKfindout.com. https://www.dkfindout.com/us/history/victorian -britain/british-empire.

Hibbert, Christopher. *Queen Victoria: A Personal History.* New York: Basic Books, 2000.

Hunt, Kristin. "Victoria and Abdul: The Friendship That Scandalized England." Smithsonian. com. https://www.smithsonianmag.com/history/victoria-and-abdul-friendship-scandalized -england-180964959.

Lange, Maggie. "Timely Report: Queen Victoria Was Very into Nudity." Thecut.com. https:// www.thecut.com/2014/05/timely-report-queen-victoria-was-into-nudity.html.

Nikkhah, Roya. "Queen Victoria's Passion for Nudity Goes on Display in New Art Exhibition." Telegraph.co.uk. http://www.telegraph.co.uk/culture/art/art-news/7228202/Queen -Victorias-passion-for-nudity-goes-on-display-in-new-art-exhibition.html.

LILIUOKALANI

Sinnott, Susan. *Extraordinary Asian Americans and Pacific Islanders.* New York: Children's Press, 2003.

Syler, Julia Flynn. *The Lost Kingdom.* New York: Atlantic Monthly Press, 2012.

MARIE

Elsberry, Terence. *Marie of Romania: The Intimate Life of a Twentieth Century Queen.* New York: St. Martin's Press, 1972.

"Marie, Queen of Romania." Maryhillmusuem.org. http://www.maryhillmuseum.org /ongoing-exhibitions/queen-marie-of-romania.

Pakula, Hannah. *The Last Romantic: A Biography of Queen Marie of Roumania.* New York: Simon and Schuster, 1984.

ACKNOWLEDGMENTS

Thank you to my editor Bridget Watson Payne for seeing the potential in this idea and giving me the freedom to execute my vision. To Shweta Jha for bringing sense to my colorful, playful views of queens in her thoughtful research and writing. To Kristen Hewitt for putting it all together in such a beautiful book. To my husband, Ken, for all the advice on the architecture of different eras and cultures, as well as for putting up with me for the year I was neck deep in research and painting. To Ece Calguner Erzan for introducing me to Roxelana and Mustafa Abadan for giving me some history on the Ottoman Empire and architecture. Finally, to my agent, Jennifer Nelson, for everything.

—JENNIFER ORKIN LEWIS

Huge thanks to Bridget Watson Payne, my editor and friend. Thanks also to Jennifer Orkin Lewis for her exquisite illustrations—it was a true pleasure to write alongside such beautiful work. Thanks to the San Francisco Public Library and the J. Paul Leonard Library at San Francisco State University, instrumental to my research. Special thanks to SFSU student Andrew Pannell, who saved the day with his kindness. To my sister Nalini Rajagopal, thanks for your enduring confidence in me, in this and everything else. Endless love and gratitude goes to my mom, Padma Govindarajan, who cared for my daughters so I could write, and to my dad, Raj Govindarajan, for his constant encouragement. Thanks so much to Carrie Seim for being my eternal cheerleader. To my husband, Vinayak, my greatest love and best friend: You're the reason I can call myself a writer. And to Aishwarya and Sahana: May the valor and wisdom of these twenty women be your guiding light through the deep, vast world.

—SHWETA JHA

Jennifer Orkin Lewis is an artist, illustrator, and author living in New York. Her illustrations have been featured on products for Anthropologie, Kate Spade, and more. Her previous books include *Draw Every Day, Draw Every Way* and *Love Found* (also from Chronicle Books). You can see more of her work at www.augustwren.com.

Shweta Jha is a writer and freelance journalist. Her work has been featured in the *New York Post* and the *Los Angeles Times*, among others. She is currently working on her first novel. She lives in San Francisco.